M000031933

COOL SHOPS
LOS ANGELES

teNeues

Imprint

Editors:	Karin Mahle, Katharina Feuer
Photos (location):	Benny Chan (Chan Luu, Costume National, Hennessey + Ingalls, l.a. Eyeworks), Martin Nicholas Kunz (Noodle Stories), courtesy Trina Turk Los Angeles Boutique (Trina Turk Boutique) All other photos by Katharina Feuer & Michelle Galindo.
Introduction:	Karin Mahle
Layout:	Katharina Feuer
Imaging & Pre-press:	Susanne Olbrich
Map:	go4media. – Verlagsbüro, Stuttgart
Translations:	SAW Communications, Dr. Sabine A. Werner, Mainz Martina Fischer (German), Céline Verschelde (French), Silvia Gomez de Antonio (Spanish), Elena Nobilini (Italian), Dr. Suzanne Kirkbright (English)

Produced by fusion publishing GmbH, Stuttgart . Los Angeles
www.fusion-publishing.com

Published by teNeues Publishing Group

teNeues Publishing Company
16 West 22nd Street, New York, NY 10010, USA
Tel.: 001-212-627-9090, Fax: 001-212-627-9511

teNeues Book Division
Kaistraße 18, 40221 Düsseldorf, Germany
Tel.: 0049-(0)211-994597-0, Fax: 0049-(0)211-994597-40

teNeues Publishing UK Ltd.
P.O. Box 402, West Byfleet, KT14 7ZF, Great Britain
Tel.: 0044-1932-403509, Fax: 0044-1932-403514

teNeues France S.A.R.L.
4, rue de Valence, 75005 Paris, France
Tel.: 0033-1-55766205, Fax: 0033-1-55766419

teNeues Iberica S.L.
Pso Juan de la Encina 2-48, Urb Club de Campo
28700 S.S.R.R. Madrid, Spain
Tel./Fax: 0034-91-65 95 876

www.teneues.com

ISBN:	3-8327-9071-3

© 2005 teNeues Verlag GmbH + Co. KG, Kempen

Printed in Italy

Picture and text rights reserved for all countries.
No part of this publication may be reproduced in any
manner whatsoever.

All rights reserved.

While we strive for utmost precision in every detail,
we cannot be held responsible for any inaccuracies,
neither for any subsequent loss or damage arising.

Bibliographic information published by
Die Deutsche Bibliothek. Die Deutsche Bibliothek lists
this publication in the Deutsche Nationalbibliografie;
detailed bibliographic data is available in the Internet
at http://dnb.ddb.de.

Contents	Page

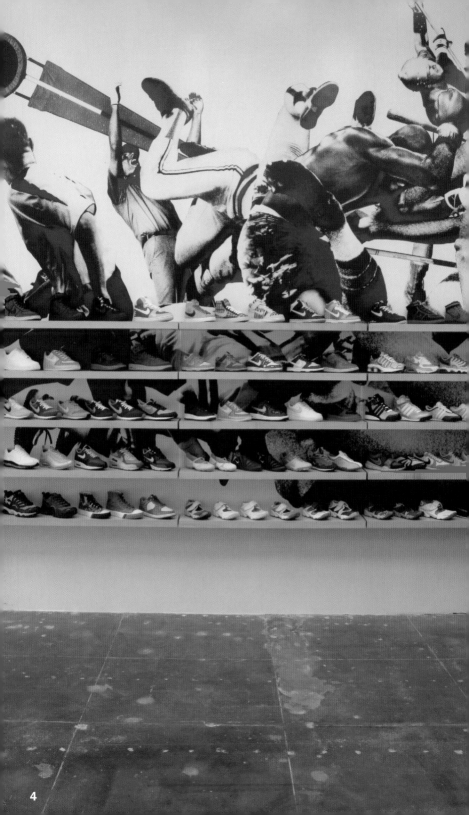

Introduction

Los Angeles is, just by its sheer size and creative industries, a great place to shop. A few added factors make it one of the best:

In the fast growing 20's, many garages, warehouses and small residential buildings were turned into stores, a trend that is having a revival in stores like Hollyhock, Stella McCartney and Salt.

The mild climate allows stores to open whole storefronts to the public and let the ocean breezes in as in the Equator Bookstore near the beach and James Perse, a t-shirt store with a movable exterior wall. The "surfboard-store in a garage" theme adds a casual air to the design and the layout. Inexpensive materials, unusually large spaces, natural light and areas just to socialize are all a part of an edgier, younger approach to retail than anywhere else.

Stores are increasingly seen as the center of a social circle. Movie stars have after-hours privileges and appreciate locations away from Rodeo Drive. Melrose Place is the most discreet of shopping streets and stores like Marni are definitely not designed for window-shopping. They are more like retail clubs, less designed to showcase the clothes than to create a comfortable environment to plan next year's wardrobe.

Cool Shops Los Angeles will lead you away from the obvious list of stores that you will find in every major city and introduce you to the places where the locals meet, shop and talk. All you need is a car, a map and sun block!

Karin Mahle

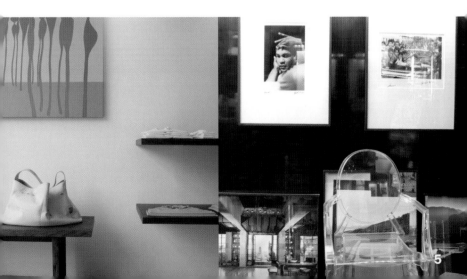

Einleitung

Los Angeles ist allein schon wegen seiner gewaltigen Größe und der kreativen Sze ne eine tolle Stadt zum Einkaufen. Durch ein paar zusätzliche Faktoren wird es zu einem richtigen Shoppingparadies:

In den von raschem Wachstum geprägten 1920er-Jahren wurden viele Garagen, Lagerhäuser und kleine Wohngebäude in Geschäfte umgewandelt. Dieser Trend e lebt derzeit in Läden wie Hollyhock, Stella McCartney und Salt ein Revival.

In dem milden Klima öffnen Läden ihre gesamte Vorderfront und neben der Kund schaft kann auch eine frische Meeresbrise hereinströmen, wie zum Beispiel im Equator Bookstore am Strand und bei James Perse, einem T-Shirt-Geschäft mit e ner beweglichen Außenwand. Durch das „Surfbrett-Laden in der Garage"-Konzept bekommen das Design und die Struktur der Läden einen lässigen Touch. Günstige Materialien, ungewöhnlich große Räume, natürliches Licht und Kommunikationsb reiche: Dieses Einzelhandelskonzept ist spannend und trendy – mehr als irgendwo sonst.

Geschäfte werden zunehmend als Mittelpunkt des gesellschaftlichen Lebens be trachtet. Filmstars genießen hier Sonderrechte, kaufen außerhalb der normalen Geschäftszeiten ein und wissen Läden zu schätzen, die nicht direkt am Rodeo Drive liegen. Melrose Place ist die diskreteste Einkaufsstraße, und Geschäfte wie Marni sind eindeutig nicht fürs Window-Shopping ausgelegt. Sie haben eher eine Clubatmosphäre und ihr Sinn und Zweck liegt weniger in der Präsentation von Kle dung, sondern es soll eine gemütliche Umgebung geschaffen werden, in der man die Garderobe des kommenden Jahres planen kann.

Cool Shops Los Angeles führt Sie weg von den üblichen Läden, die in jeder größe ren Stadt zu finden sind, hin zu den Orten, an denen sich die Los Angelenos tref fen, wo sie einkaufen und sich unterhalten. Sie brauchen nur ein Auto, eine Stra ßenkarte und Sonnencreme!

Karin Mah

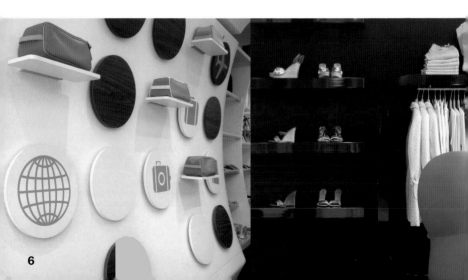

Introduction

Los Angeles est une ville géniale pour faire du shopping rien que par sa taille gigantesque et ses quartiers branchés. Quelques facteurs supplémentaires font d'elle un véritable paradis du shopping :

Au cours des années 20 marquées par une croissance rapide, de nombreux garages, entrepôts et petits immeubles ont été transformés en magasins ; cette tendance connaît un renouveau dans des magasins tels que Hollyhock, Stella McCartney et Salt.

Le climat doux permet aux boutiques d'ouvrir complètement leur façade par laquelle une brise de mer fraîche peut entrer, parallèlement à la clientèle, comme par exemple au Equator Bookstore le long de la plage et au James Perse, un magasin de tee-shirts comprenant un mur extérieur mobile. Le concept du « magasin de planche de surf dans un garage » confère au design et à l'agencement une ambiance de nonchalance. Des matériaux peu chers, des salles de taille inhabituelle, de la lumière naturelle et des zones favorisant la communication : ici plus qu'ailleurs, ce concept des petits commerces est intéressant et à la mode.

Les magasins sont de plus en plus considérés comme le point central de la société. Ici, les stars de cinéma jouissent de privilèges, peuvent faire leurs achats en dehors des horaires d'ouverture classiques et apprécient les boutiques qui ne se trouvent pas directement sur le Rodeo Drive. Melrose Place est la rue commerçante la plus discrète et il est évident que des magasins comme Marni ne sont pas conçus pour le lèche-vitrine. Dans ces magasins, on retrouve plutôt l'ambiance d'un club ; ils ne servent pas vraiment à exposer des vêtements, mais ont pour objectif de créer un environnement de confort dans lequel on peut réfléchir à sa garde-robe de l'année à venir.

Cool Shops Los Angeles vous emmène loin des boutiques classiques que l'on trouve dans toutes les grandes villes et vous fait découvrir les endroits où les habitants de Los Angeles se retrouvent, où ils vont faire leurs courses et où ils se rencontrent pour discuter. Tout ce dont vous avez besoin, c'est d'une voiture, d'une carte et de crème solaire !

Karin Mahle

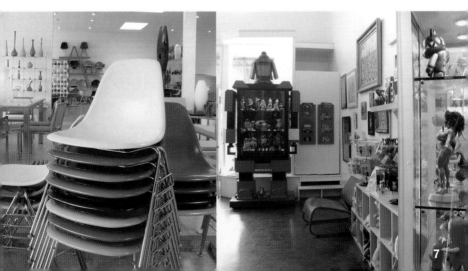

Introducción

Sus gigantescas dimensiones y la creatividad de sus tiendas hacen de Los Ángeles una ciudad ideal para las compras. Además, hay otros factores que la convier ten en verdadero paraíso para ir de tiendas:

Durante la década de 1920, que estuvo marcada por un crecimiento vertiginoso, un gran número de garajes, almacenes y pequeños edificios de viviendas fueron transformados en comercios. Hoy en día, esta tendencia vuelve a resurgir en tien das como Hollyhock, Stella McCartney y Salt.

El clima templado de la ciudad permite diseñar los comercios con la fachada fror tal abierta para que la clientela y la fresca brisa marina puedan entrar en la tien da. Ejemplos de este diseño son la librería Equator Bookstore, en la playa, y la tienda de camisetas James Perse, con una pared exterior corredera. El concepto de la "tienda de tablas de surf en un garaje" dota al diseño y a la estructura de las tiendas de una atmósfera desenfadada. El empleo de materiales baratos, la inusitada amplitud de los espacios, la luz natural y las zonas donde reunirse son características de un concepto de comercio interesante y actual cuyo mayor expc nente es la ciudad de Los Ángeles.

Las tiendas se consideran cada vez más el centro del círculo social. Las estrellas del cine disfrutan del privilegio de horarios especiales de apertura y aprecian las tiendas alejadas de Rodeo Drive. Melrose Place es la calle comercial más discret de la ciudad y en ella, tiendas como Marni se alejan del concepto de comercio con escaparate. Estas tiendas apuestan por una atmósfera más similar a la de u club donde lo importante no es la exhibición de la ropa, sino el crear un ambient agradable donde planear el vestuario del siguiente año.

En Cool Shops Los Ángeles no le mostramos las tiendas convencionales que se pueden encontrar en todas las grandes ciudades, sino que le llevamos a los luga res donde los habitantes de la ciudad quedan, van de compras y se divierten. ¡Sc lo necesita es un coche, un plano y crema de protección solar!

Karin Mah

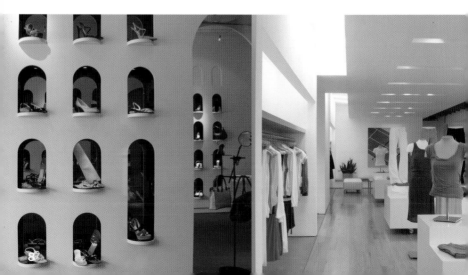

ntroduzione

ià solo per le sue dimensioni impressionanti e per i suoi ambienti creativi, Los
ngeles è una città fantastica per fare compere. Alcuni altri fattori la rendono poi
n vero paradiso dello shopping:

egli anni '20, un periodo segnato da una rapida crescita, molti garage, magazzini
 piccoli edifici ad uso abitativo furono trasformati in negozi. Questa tendenza vie-
e riproposta oggi da negozi quali Hollyhock, Stella McCartney e Salt.

n questo clima mite i negozi aprono completamente le proprie facciate anteriori,
ttraverso le quali gli ambienti vengono investiti da folate non soltanto di clientela,
na anche di fresca brezza marina, per esempio all'Equator Bookstore, situato di-
ettamente sulla spiaggia, e da James Perse, un negozio di t-shirt con una parete
sterna mobile. La concezione di "negozio di tavole da surf in un garage" conferi-
ce al design e alle strutture dei negozi un tocco disinvolto. Materiali economici,
pazi insolitamente ampi, luce naturale e zone di comunicazione: questa concezio-
e di commercio al minuto è avvincente e trendy, più che in qualsiasi altro posto.

negozi sono considerati sempre più spesso il centro della vita sociale. Le stelle
el cinema godono qui di privilegi, fanno compere al di fuori dei normali orari di
pertura e apprezzano i negozi non direttamente situati su Rodeo Drive. Melrose
lace è la via dello shopping più discreta, ed è evidente che negozi quali Marni
on siano progettati per il window shopping, ovvero per andare a guardare le vetri-
e. Questi negozi sono caratterizzati piuttosto da un'atmosfera da club e il loro
enso non sta tanto nel presentare vestiti quanto nel creare un ambiente acco-
liente in cui poter programmare il guardaroba dell'anno successivo.

ool Shops Los Angeles vi allontana dai soliti negozi presenti in qualsiasi grande
ittà, guidandovi invece nei luoghi in cui la gente di Los Angeles si incontra, va a
are compere e chiacchiera. Vi serviranno soltanto un'auto, uno stradario e una
rema solare!

Karin Mahle

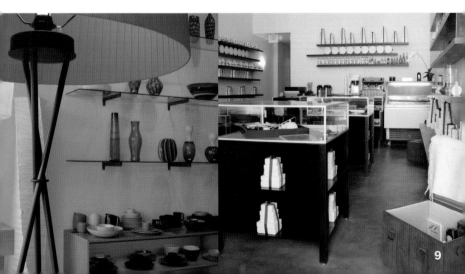

Board Gallery

Design: Ray Flores

1639 Abbot Kinney Boulevard | Los Angeles, CA 90291 | Venice
Phone: +1 310 450 4114
www.theboardgallery.com
Opening hours: Mon–Sat 11 am to 6 pm, Sun noon to 4 pm
Products: Collectable skateboards, surfboards, snowboards, clothing, DVD's
Special features: Collectable 50's & 60's modern furniture & chairs as well as antique
skateboards & surfboards

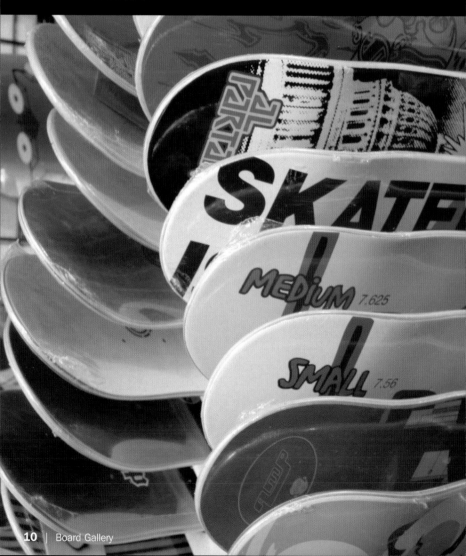

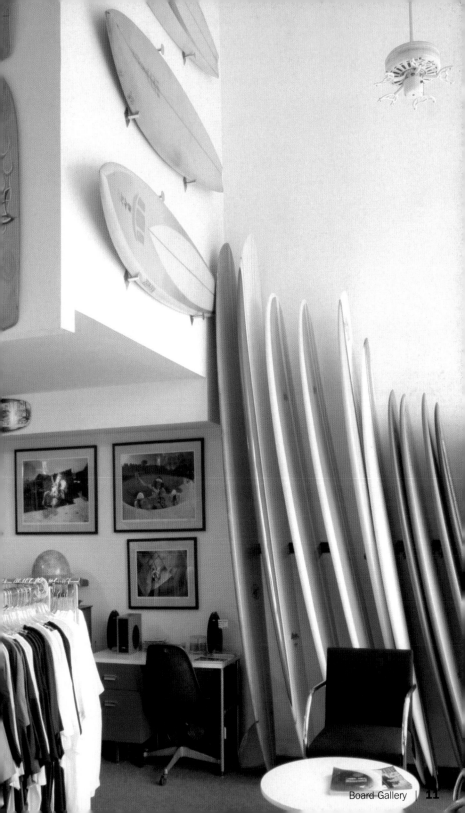

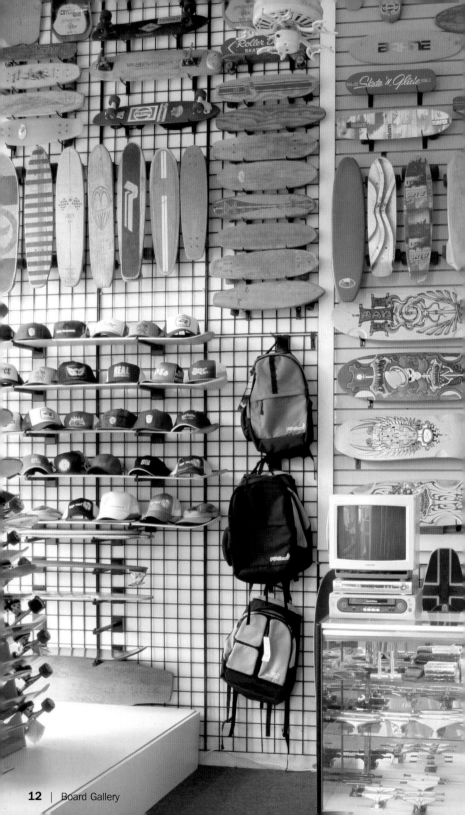

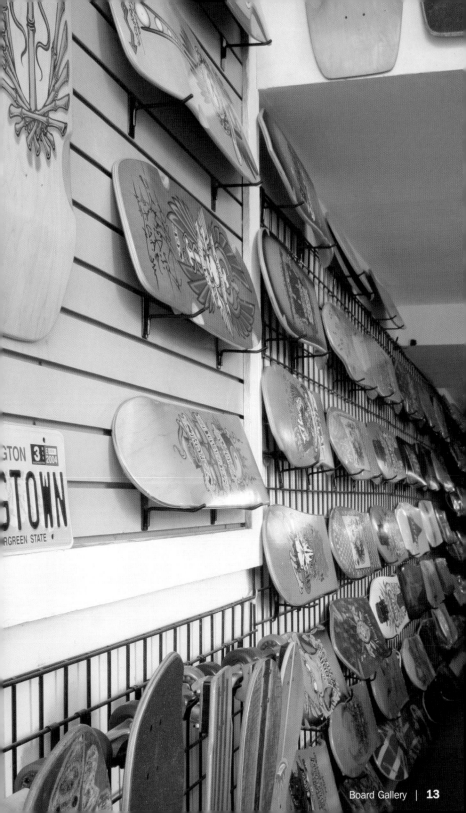

Boule

Design: Ralph Gentile Architects, Michelle Myers

420 North La Cienega Boulevard | Los Angeles, CA 90048 | West Hollywood
Phone: +1 310 289 9977
www.boulela.com
Opening hours: Wed–Sat 9 am to 7 pm, Sun 9 am to 5 pm
Products: Modern French patisserie, artisanal chocolates & confections, viennoiserie, pastries & cakes, ice creams & sorbets, gourmet sandwiches, select coffee & teas and unique specialty gifts
Special features: The Macaron, hand-dipped chocolates, custom gifts

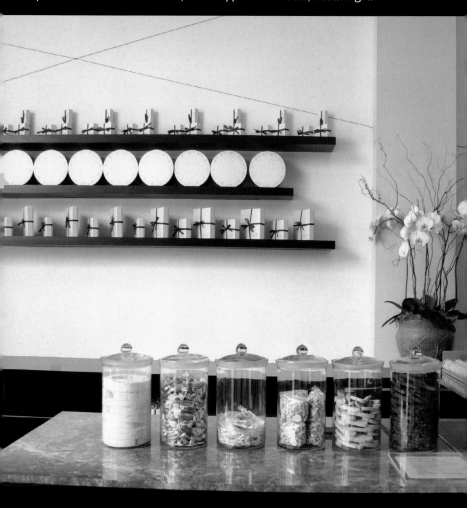

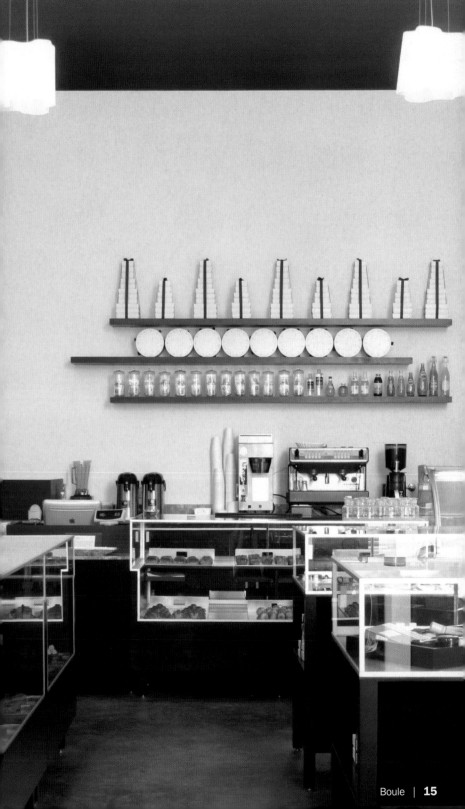

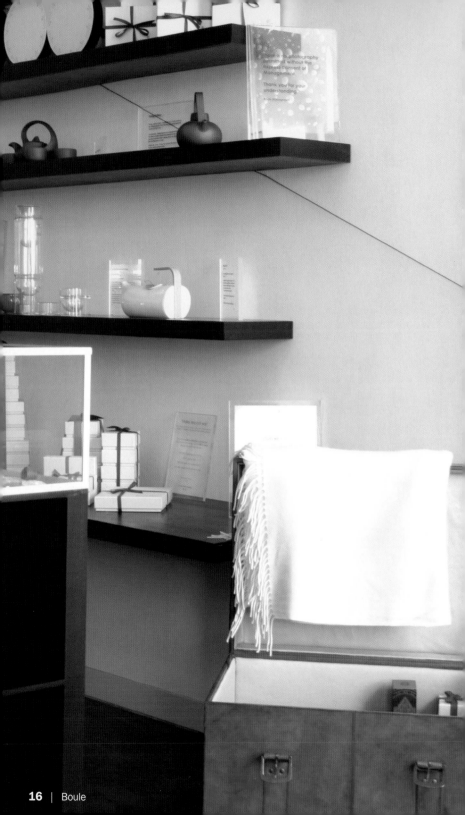

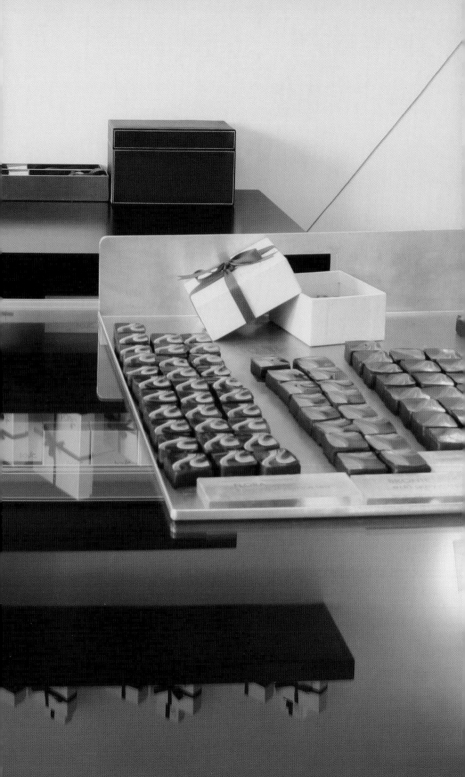

Chan Luu

Design: Marmol Radziner & Associates, www.marmol-radziner.co

112 South Robertson Boulevard | Los Angeles, CA 90048
Phone: +1 310 273 3527
Opening hours: Mon–Sat 11 am to 7 pm, Sun noon to 5 pm
Products: Jewelry, accessories and women's RTW
Special features: A-list clientele

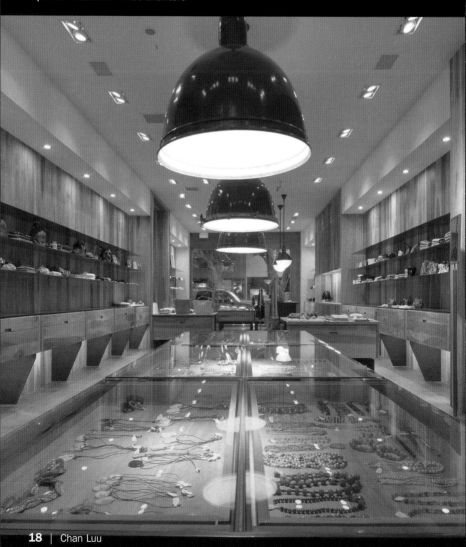

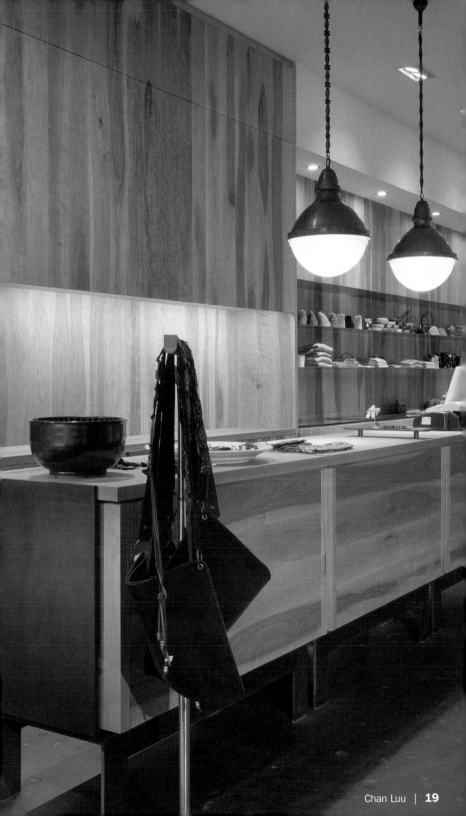

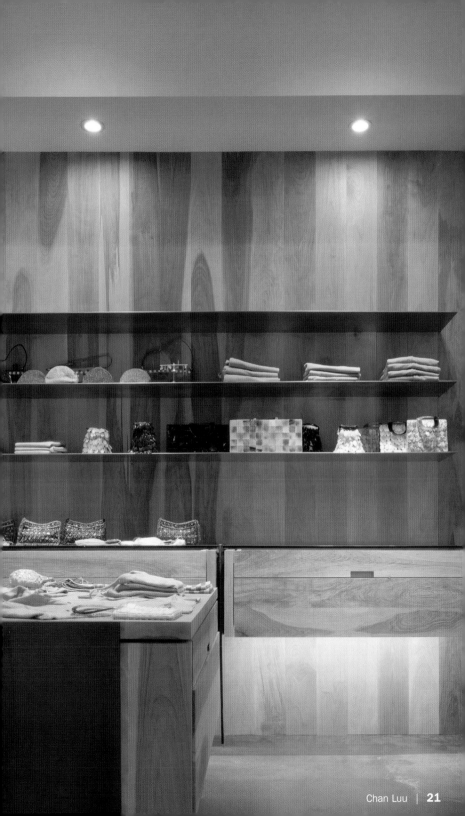

Christian Louboutin

Design: Christian Louboutin

9040 Burton Way | Los Angeles, CA 90210 | Beverly Hills
Phone: +1 310 247 9300
Opening hours: Mon–Fri 10 am to 6 pm, Sat 11 am to 6 pm, Sun closed
Products: Shoes, bags
Special features: Celebrities shoe designer

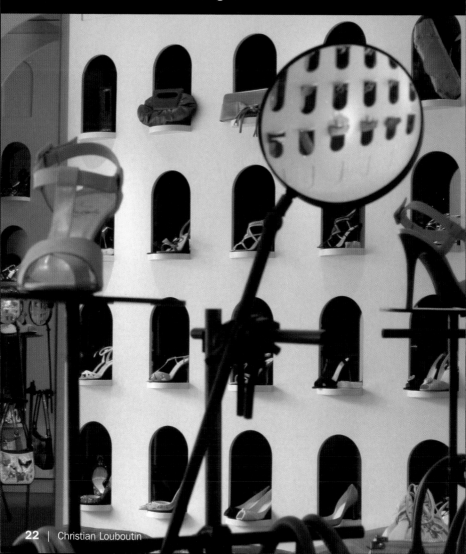

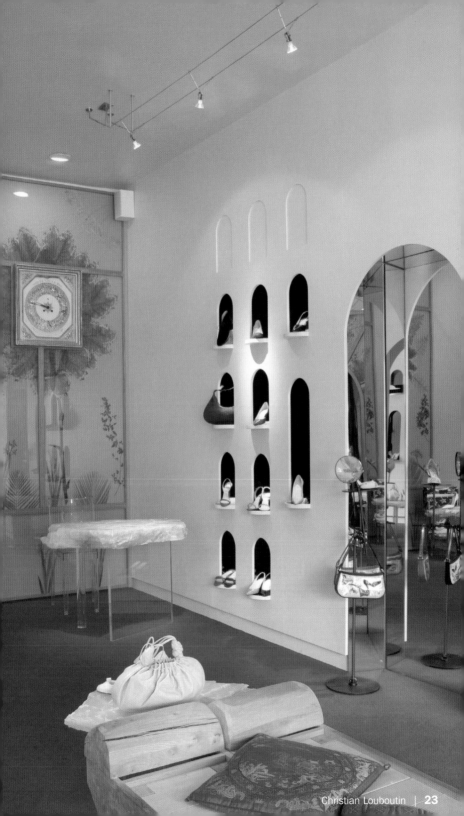

Christian Louboutin | **23**

Costume National

Design: Marmol Radziner & Associates, www.marmol-radziner.cor

8001 Melrose Avenue | Los Angeles, CA 90046 | West Hollywood
Phone: +1 323 655 8160
www.costumenational.com
Opening hours: Mon–Sat 10 am to 6 pm, Sun closed
Products: Men's and women's collections with a heavy emphasis on slim silhouettes, couture details, innovative fabrications

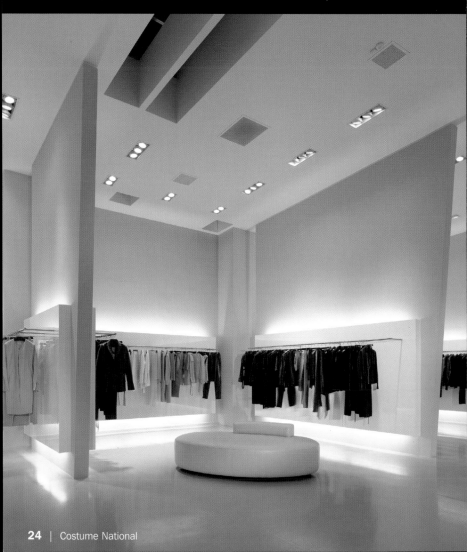

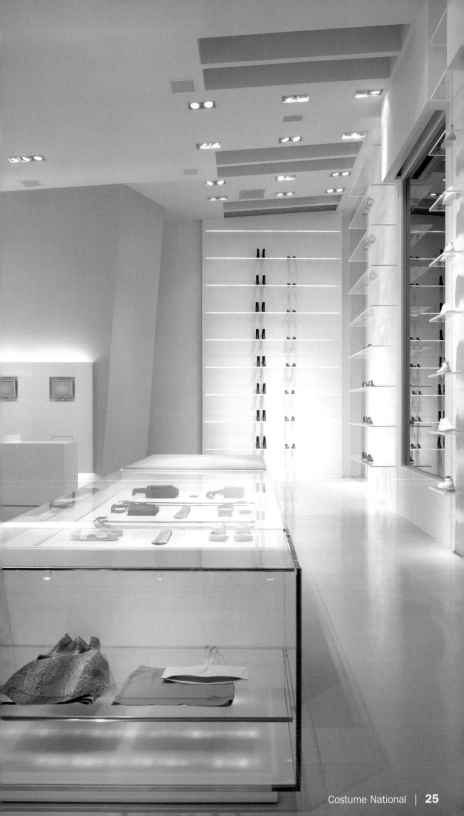

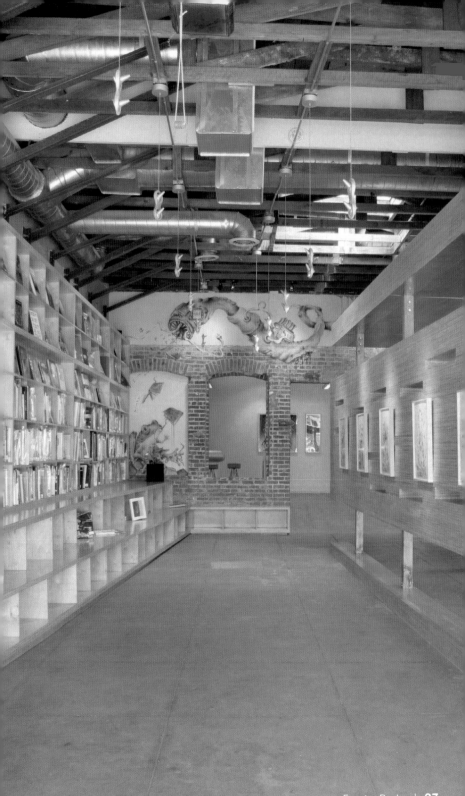

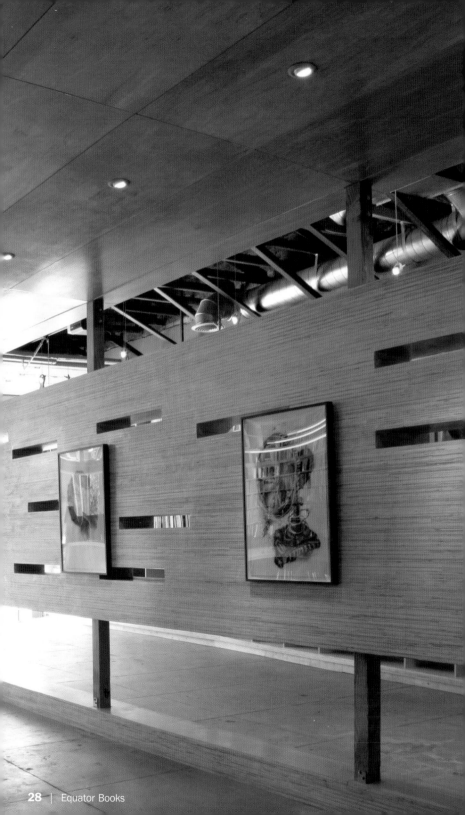

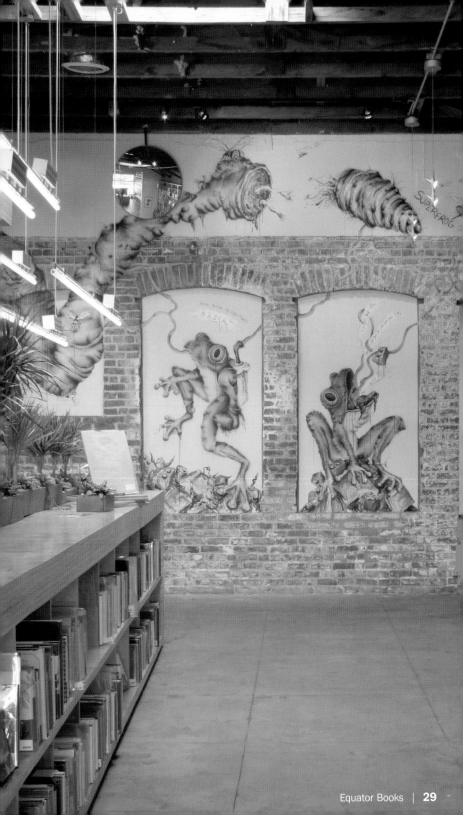

Flight 001

Design: Dario Antonioni, www.orange22.com

8235 West Third Street | Los Angeles, CA 90048 | West Hollywood
Phone: +1 323 966 0001
www.flight001.com
Opening hours: Mon–Sat 11 am to 7 pm, Sun 11 am to 6 pm
Products: Travel accessories, cosmetics, carry-on bags, guide books, stationery,
electronics, aromatherapy products

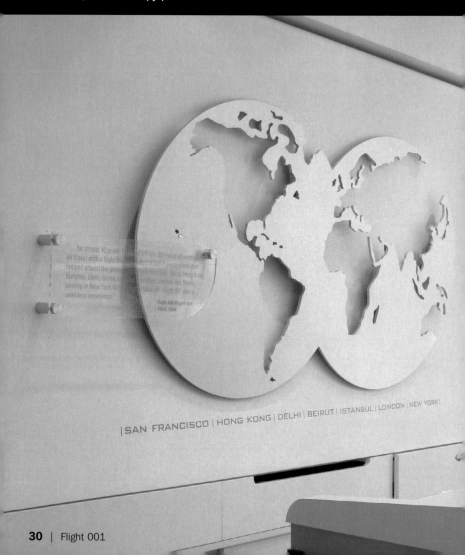

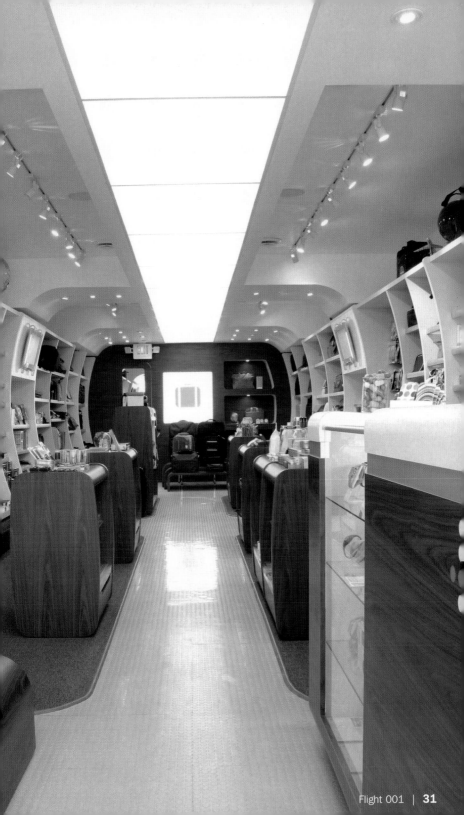

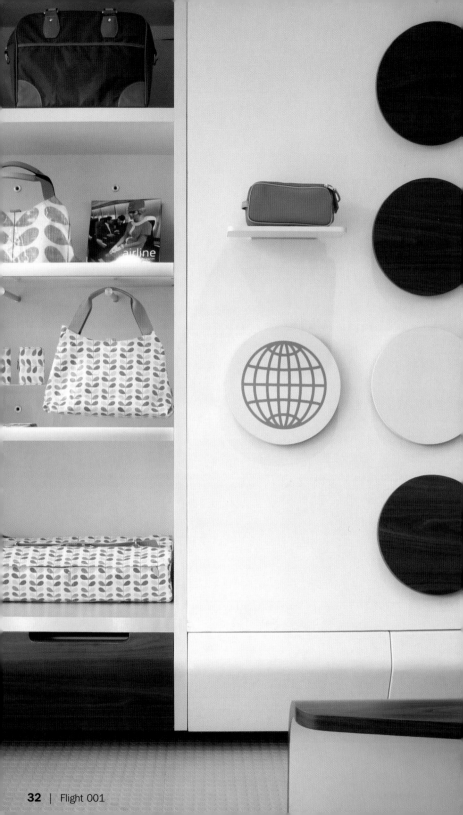

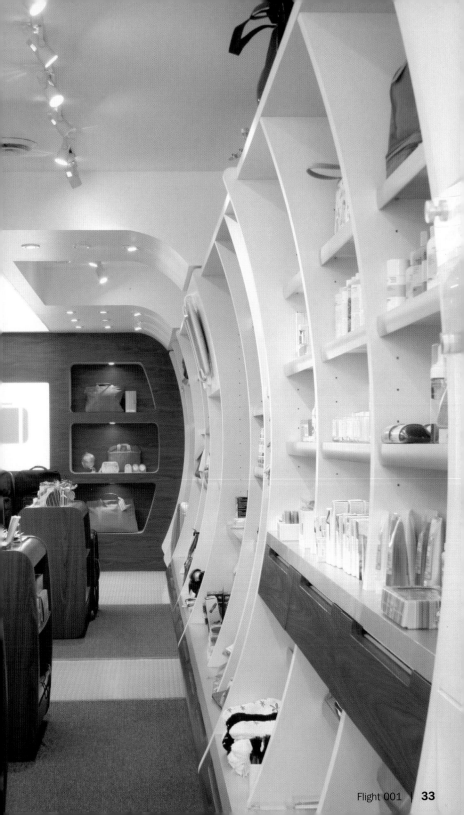

Giant Robot 2 "GR 2"

Design: Pryor Praczukowski, www.cinehous.com

2062 Sawtelle Boulevard | Los Angeles, CA 90025 | West Los Angeles
Phone: +1 310 445 9276
www.gr2.net
Opening hours: Mon–Sat 11:30 am to 8 pm, Sun noon to 7 pm
Products: Original art, prints, art objects, products relating to art, t-shirts, monographs
(art books), handmade items and publications
Special features: Monthly art exhibitions by local and international artists, occasional
receptions for film festivals and artists

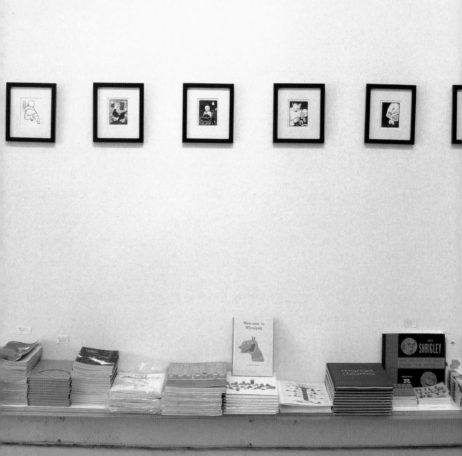

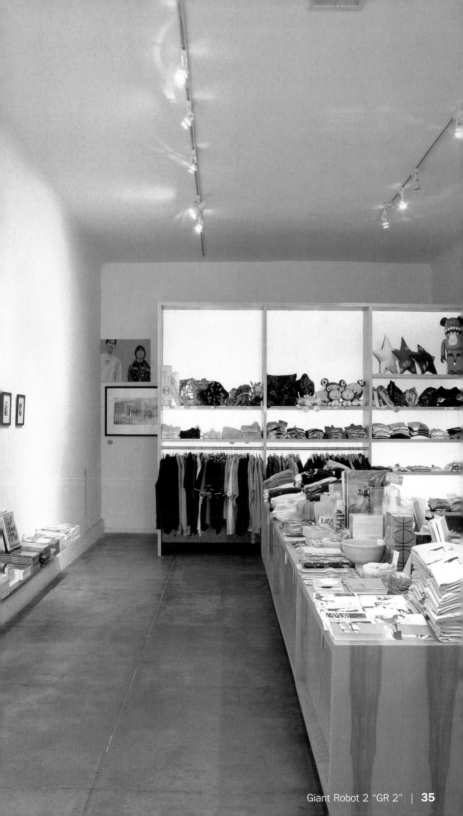

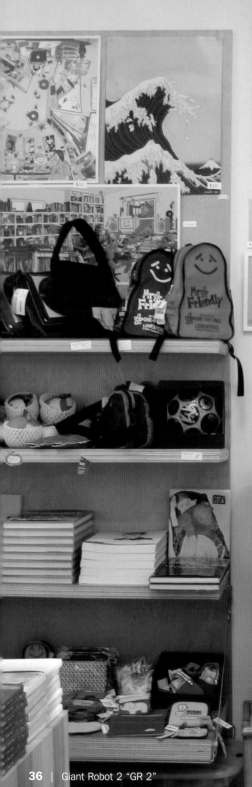

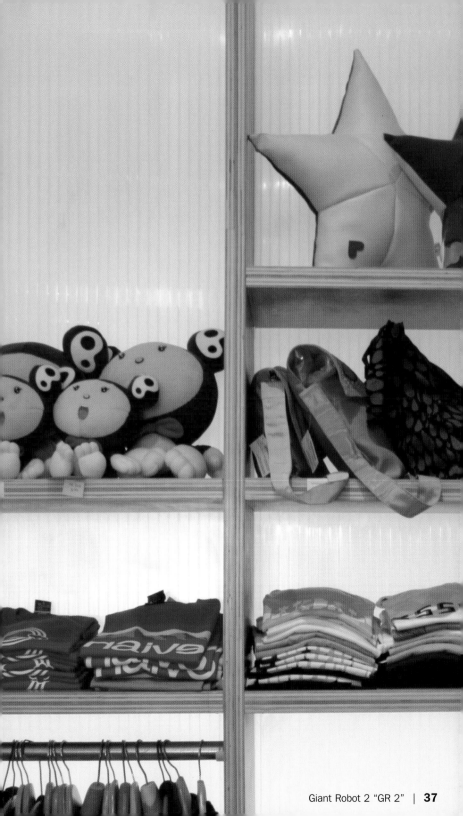

Gilly Flowers

Design: Neal Guthrie

3936 West Sunset Boulevard | Los Angeles, CA 90029 | Silverlake
Phone: +1 323 953 2910
www.gillyflowers.com
Opening hours: Mon–Thu 8:30 am to 7 pm, Fri 8:30 am to 8 pm, Sat 8:30 am to 7 pr
Sun 9 am to 4 pm
Products: Florals, gifts, ceramics, cards
Special features: Unusual, exotic blooms, neighborhood florist, "weekly mood change"

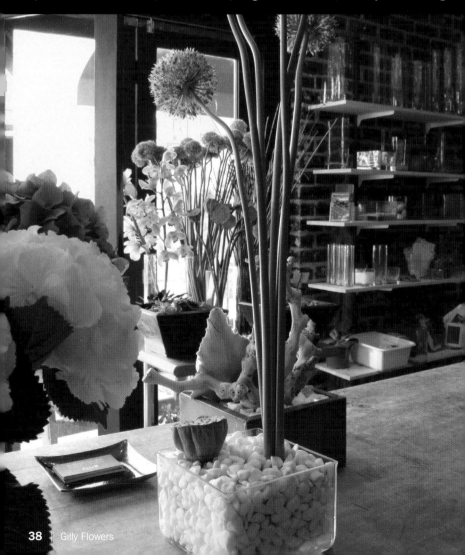

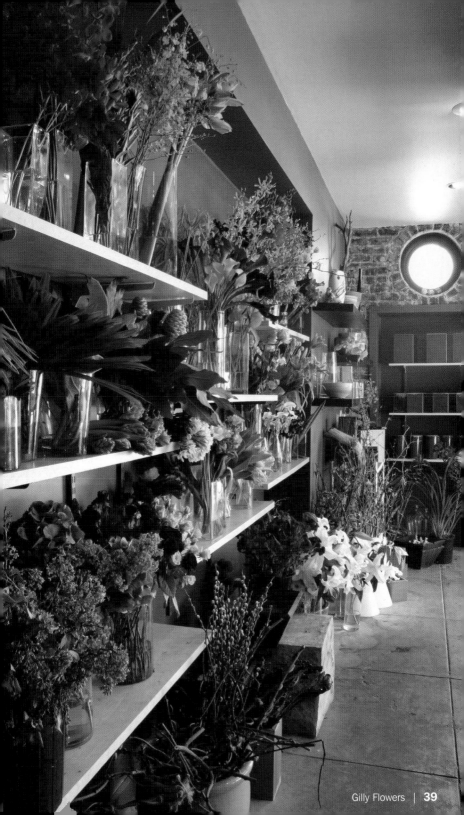

Hennessey + Ingalls

Design: Marmol Radziner & Associates, www.marmol-radziner.com

214 Wilshire Boulevard | Los Angeles, CA 90401 | Santa Monica
Phone: +1 310 458 9074
www.hennesseyingalls.com
Opening hours: Daily 10 am to 8 pm
Products: Art and architecture books
Special features: Dealing exclusively with books on the visual arts

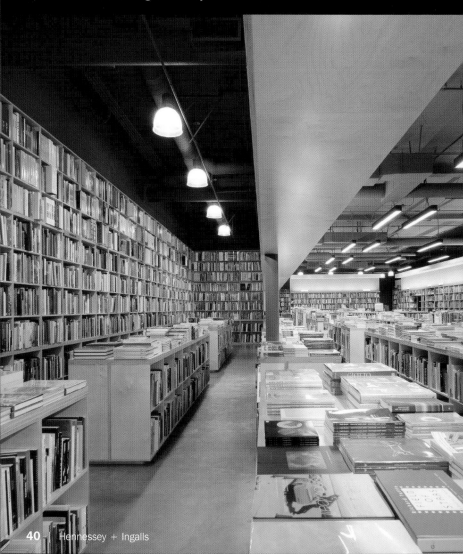

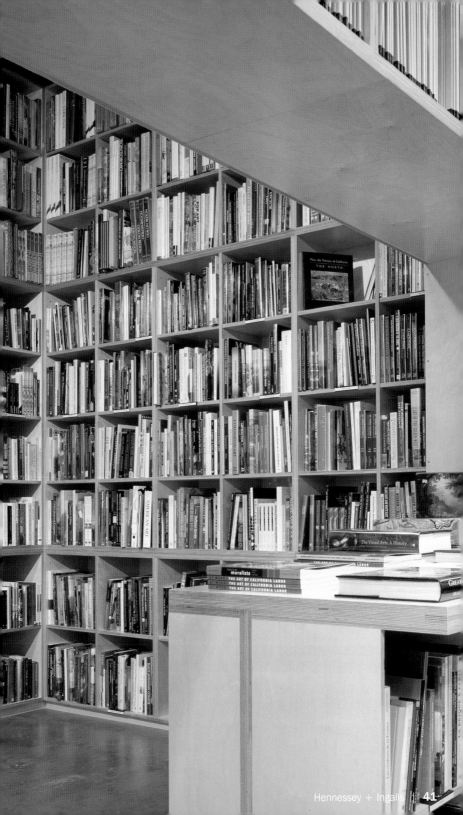

Hollyhock

Design: Suzanne Rheinstein

817 Hilldale Avenue | Los Angeles, CA 90069 | West Hollywood
Phone: +1 310 777 0100
www.hollyhockinc.com
Opening hours: Mon–Sat 10 am to 6 pm, Sun closed
Products: Furniture, antiques, accessories, books, presents

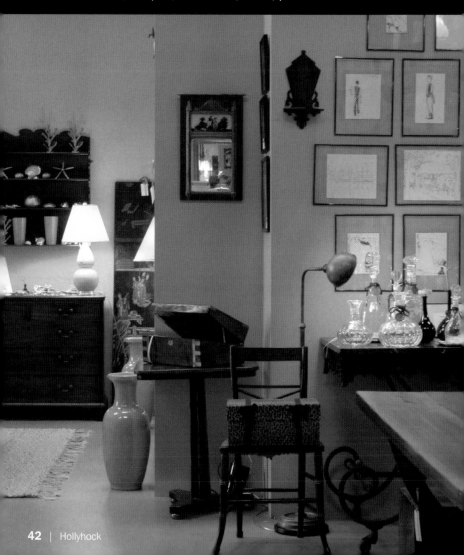

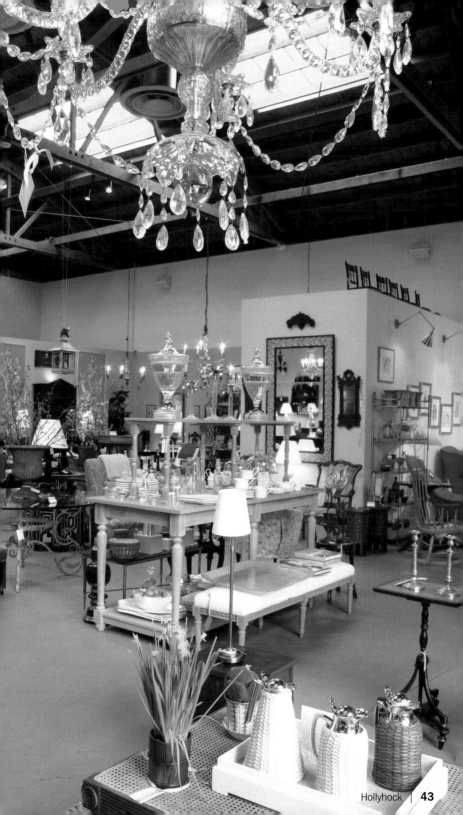

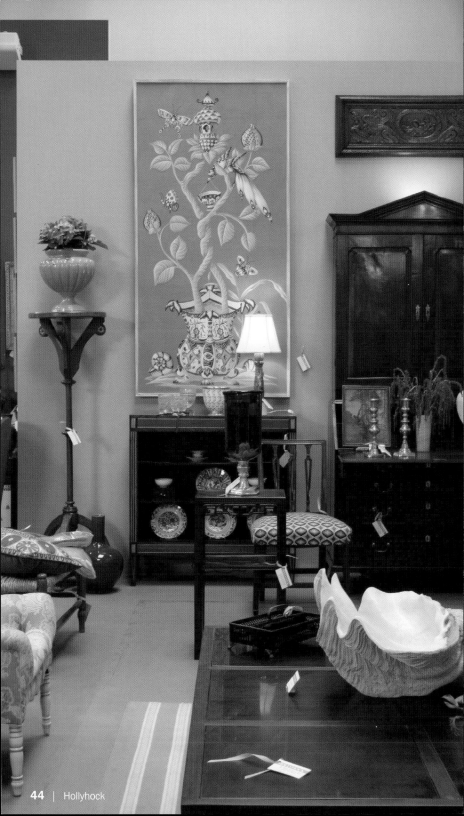

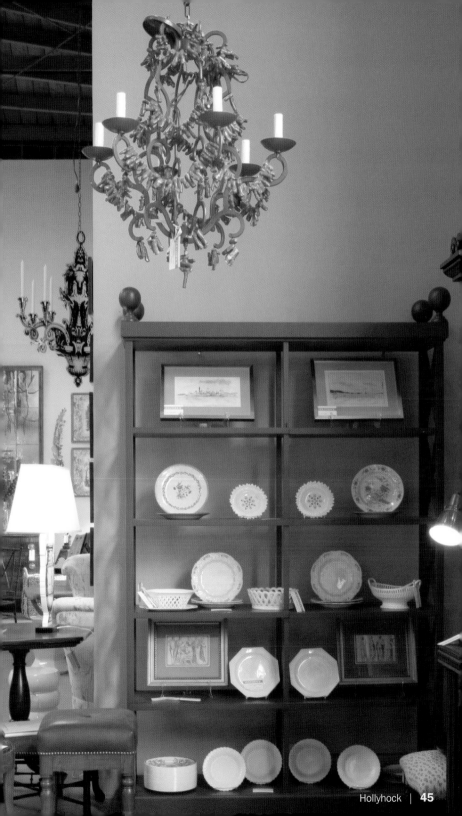

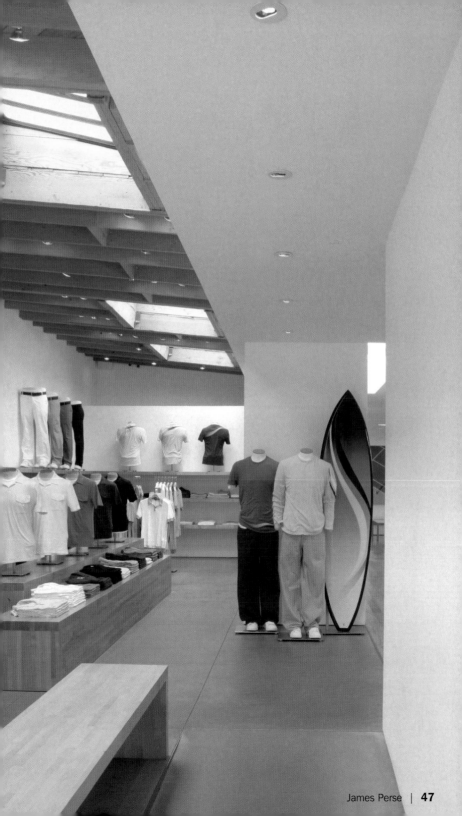

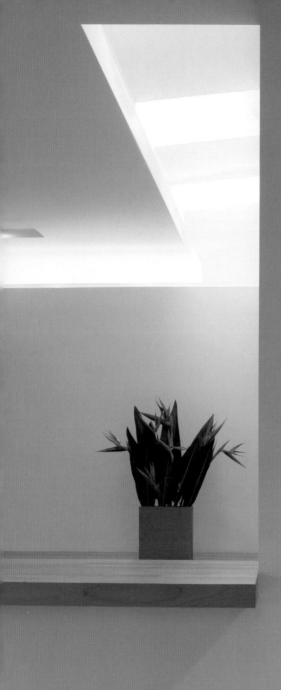

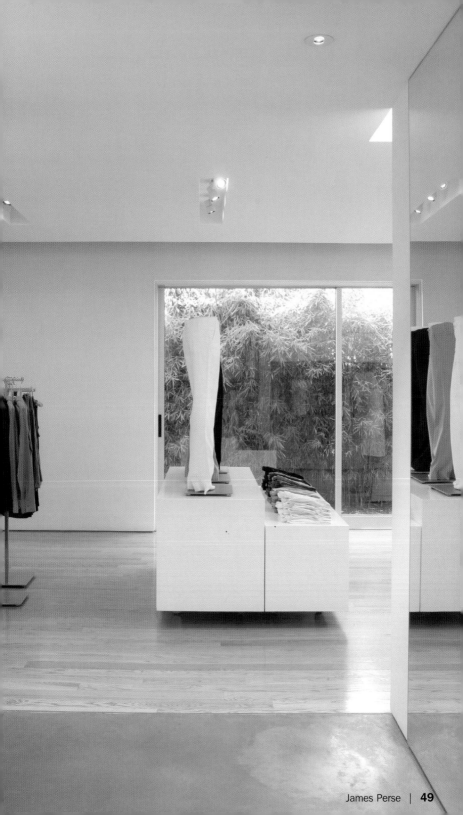

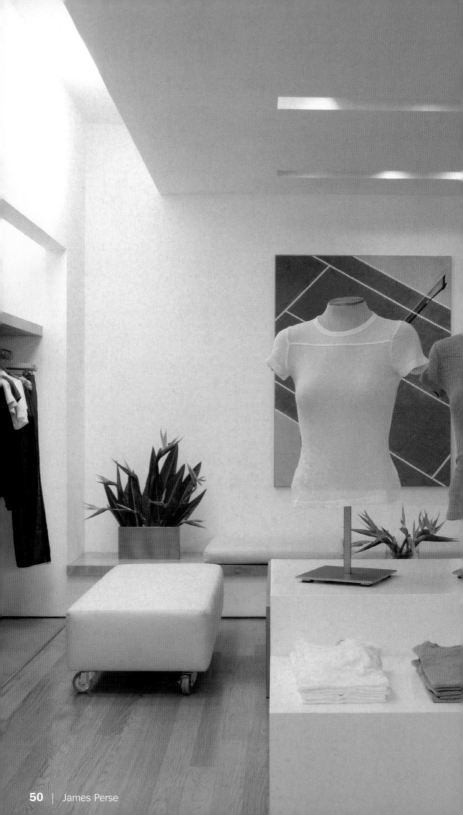

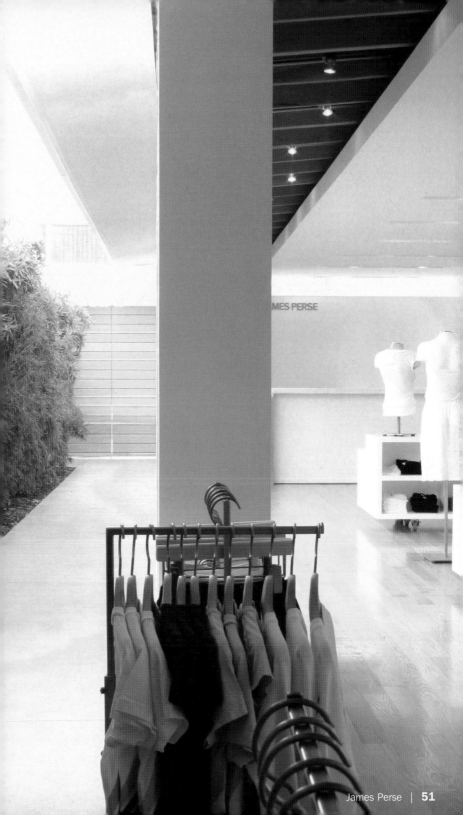

l.a. Eyeworks

Design: Neil M. Denari Architects Inc., www.nmda-inc.com
Gordon Polon Engineering (SE)

7386 Beverly Boulevard | Los Angeles, CA 90036 | Mid Wilshire
Phone: +1 323 931 7795
www.laeyeworks.com
Opening hours: Mon–Fri 10 am to 7 pm, Sat 10 am to 6 pm, Sun closed
Products: Glasses, frames, prescription lenses, accessories

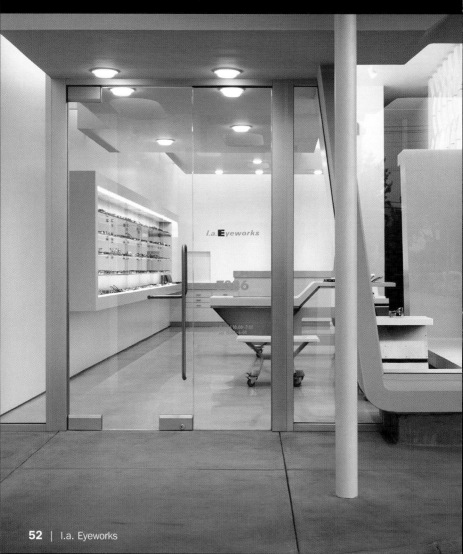

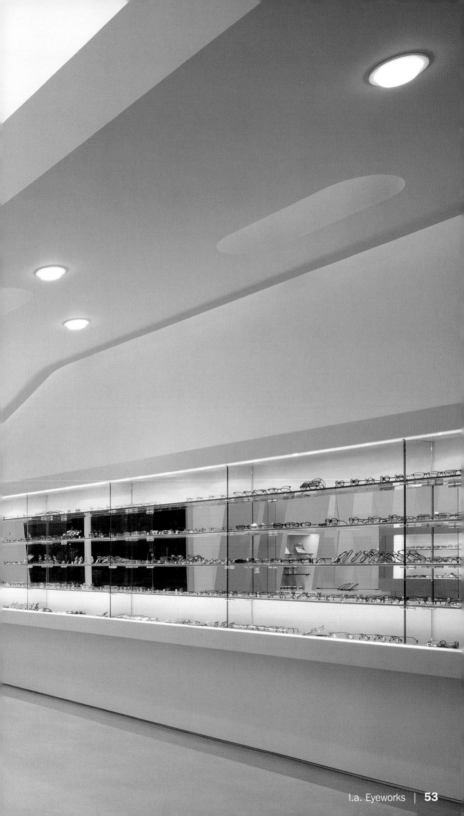

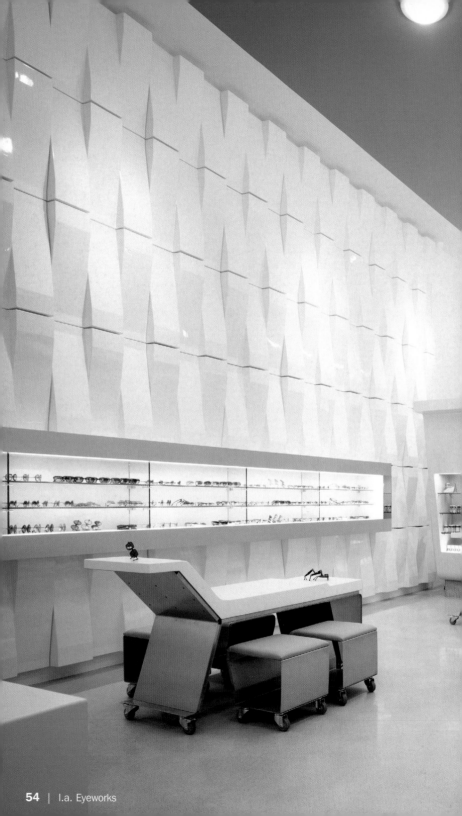

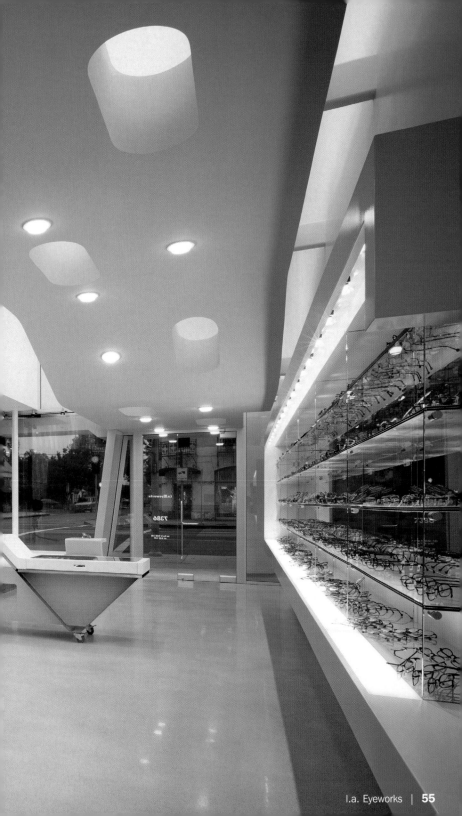

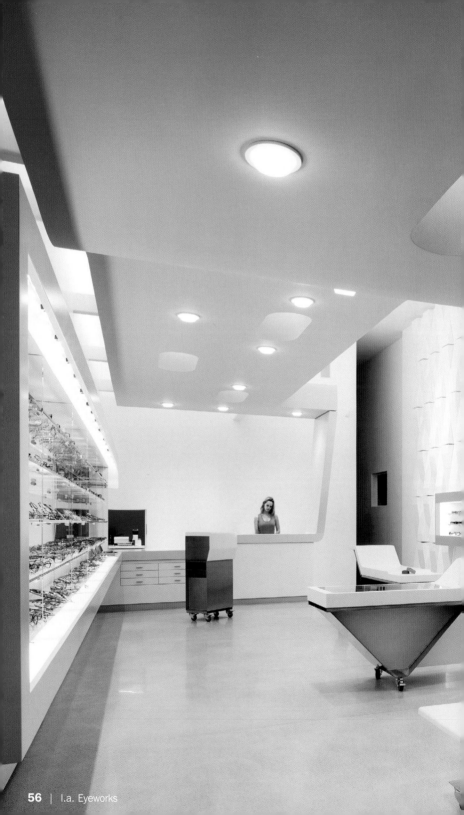

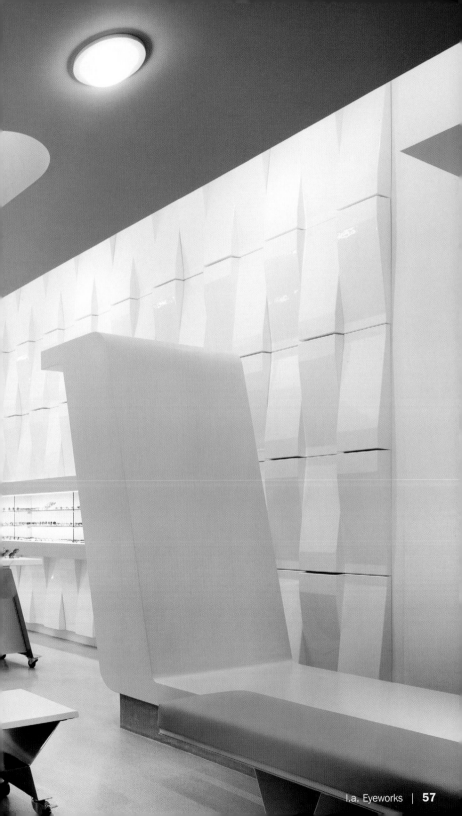

Le Palais des Thés

Design: In liaison with French headquarters

401 North Canon Drive | Los Angeles, CA 90210 | Beverly Hills
Phone: +1 310 271 7922
www.palaisdesthes.com
Opening hours: Mon–Sat 10 am to 6 pm, Sun closed
Products: Over 230 loose teas, packaged teas, tea accessories
Special features: Tasting sessions, introductory lessons, tea bar

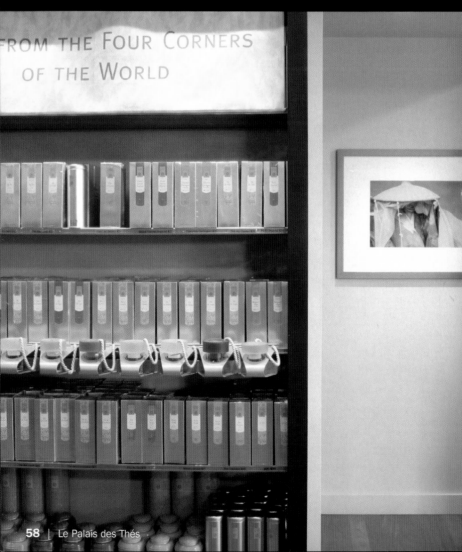

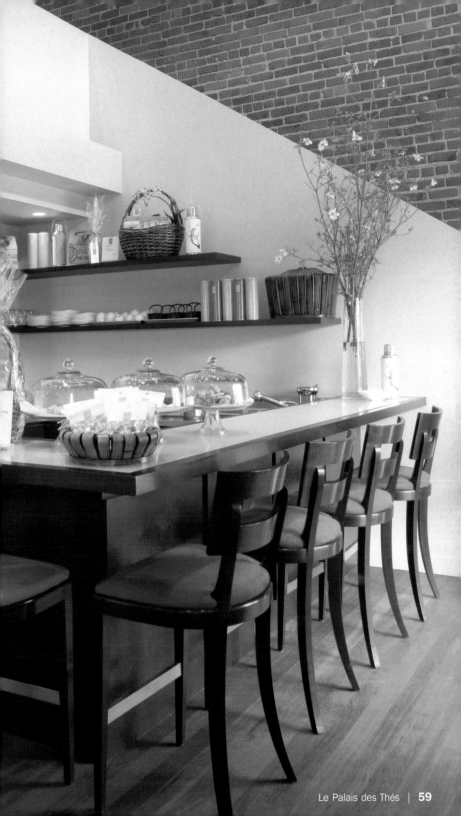

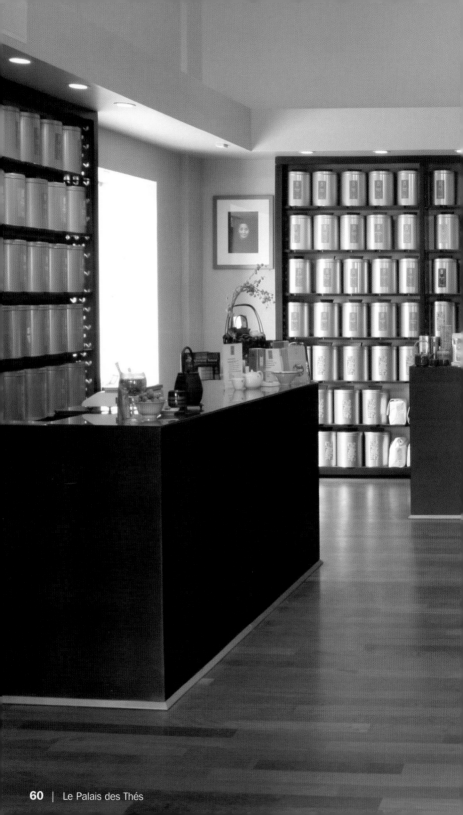

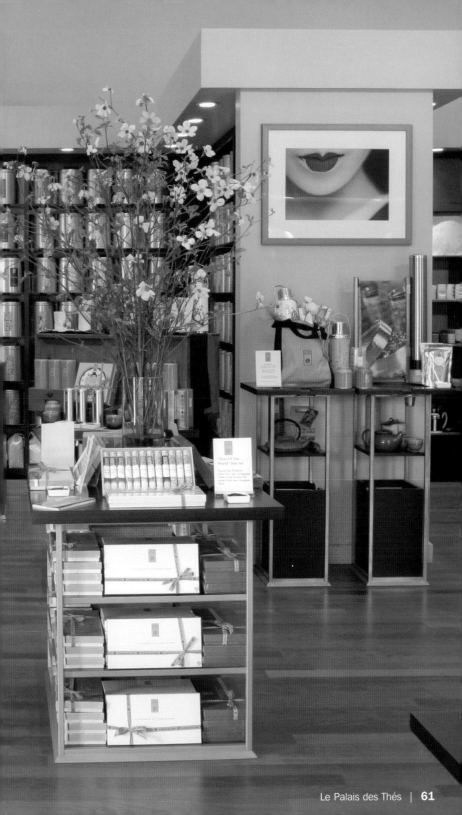

Lily et Cie

Design: Max King

9044 Burton Way | Los Angeles, CA 90211 | Beverly Hills
Phone: +1 310 724 5757
Opening hours: Tue–Fri 10 am to 6 pm, Sat 11 am to 5 pm, Mon–Sun closed
Products: 20th century American and European high end designer clothing and
accessories

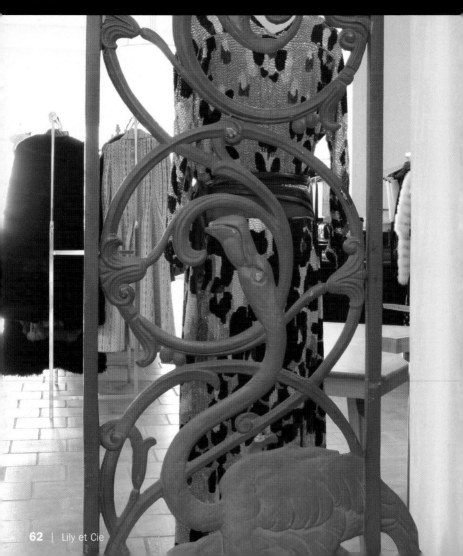

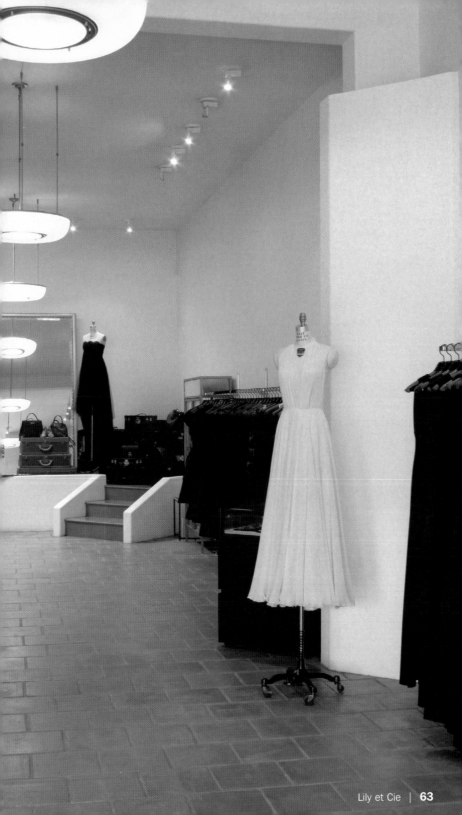

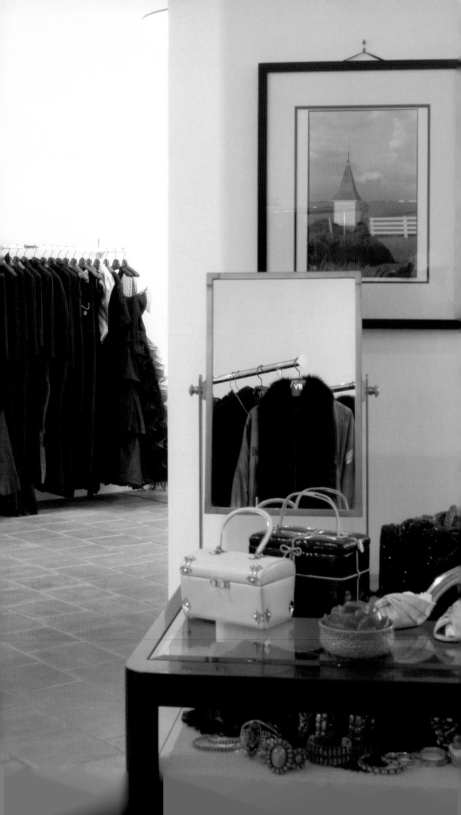

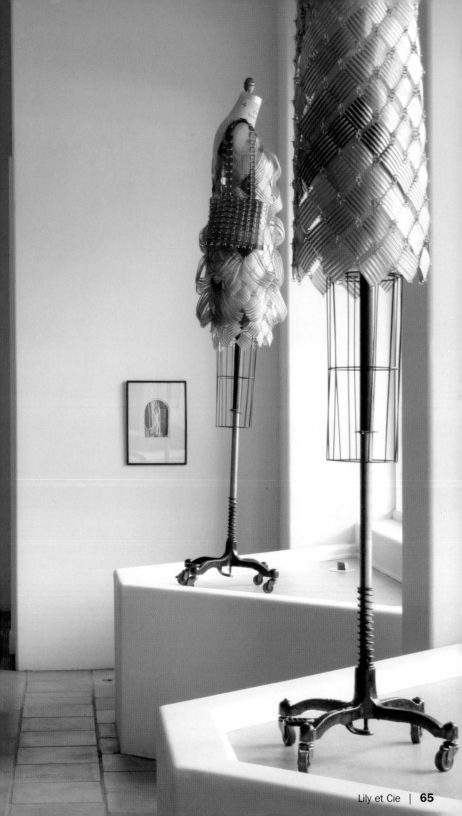

Marni

Design: Sybarite, Simon Mitchell, www.sybarite-uk.com

8460 Melrose Place | Los Angeles, CA 90069 | West Hollywood
Phone: +1 323 782 1101
www.marni.com
Opening hours: Mon–Sat 10 am to 6 pm, Sun closed
Products: Women, men ready to wear, handbags & accessories, baby size 2–10, linge
eyewear

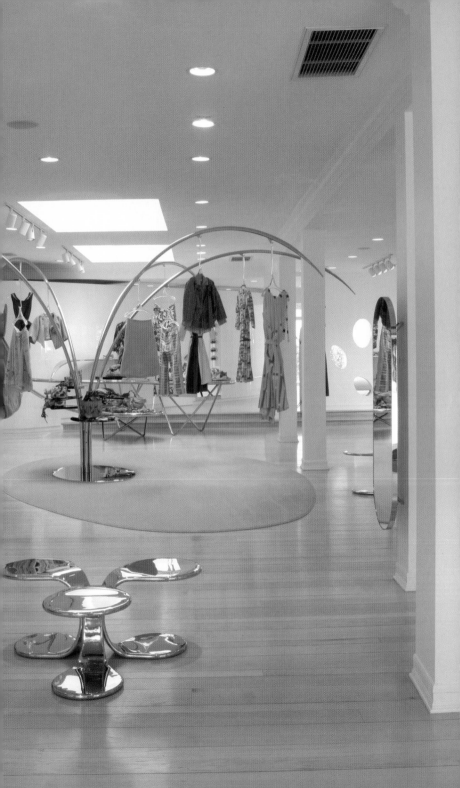

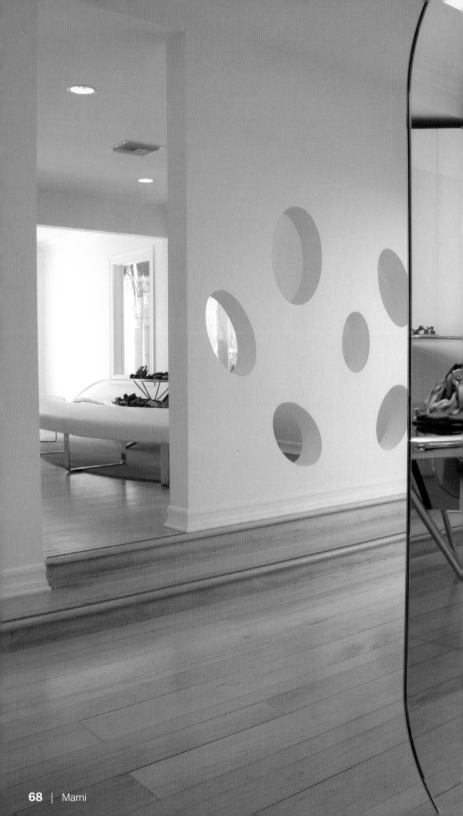

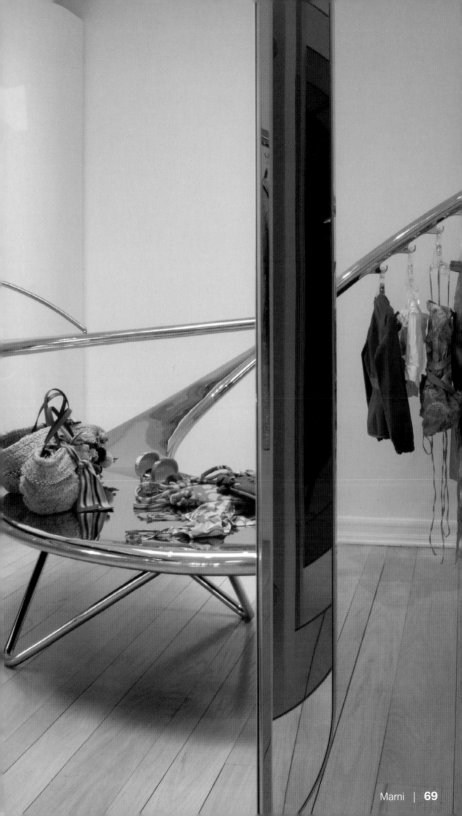

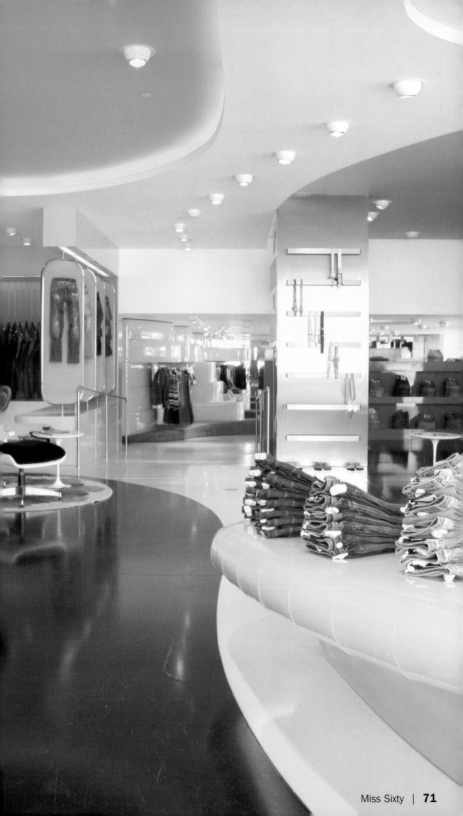

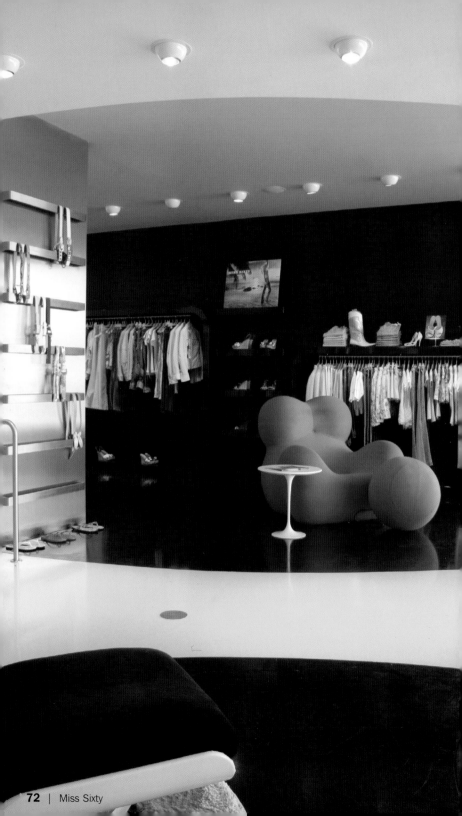

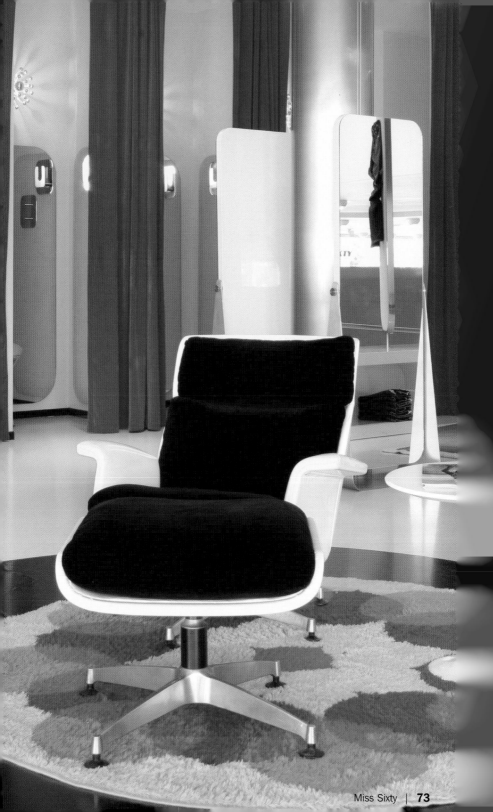

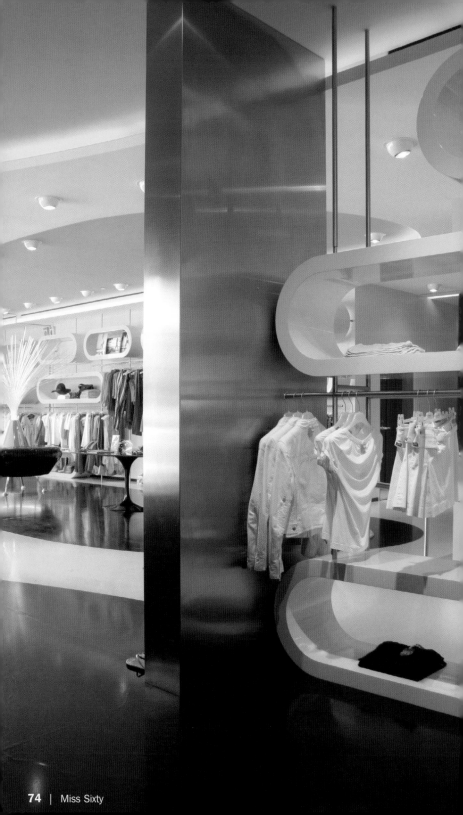

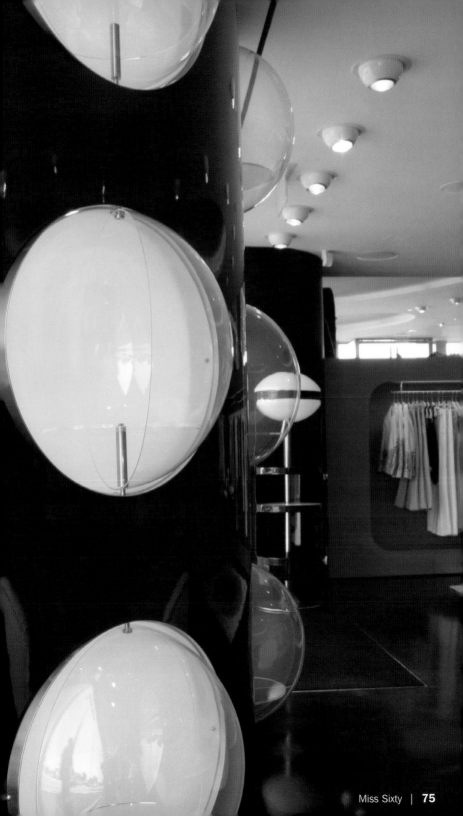

Opening hours: Mon–Fri 10 am to 6 pm, Sat 11 am to 6 pm
Products: Furniture and lighting
Special features: Classics, designer products

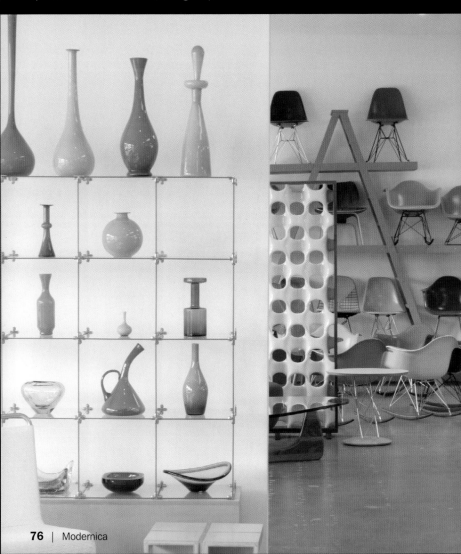

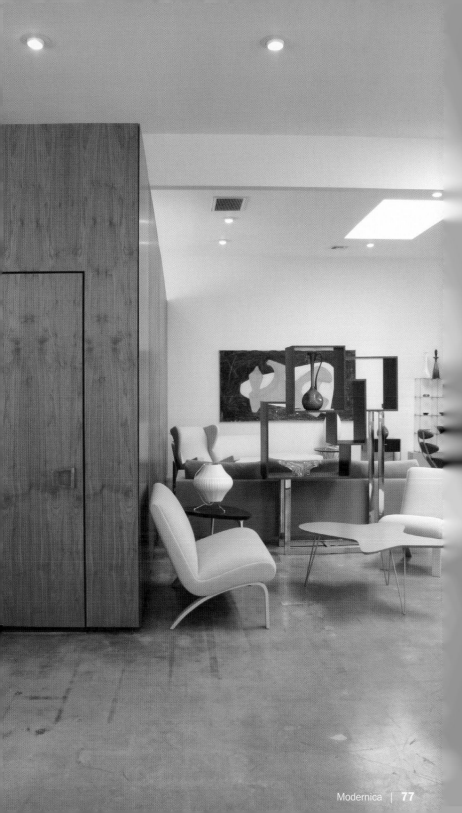

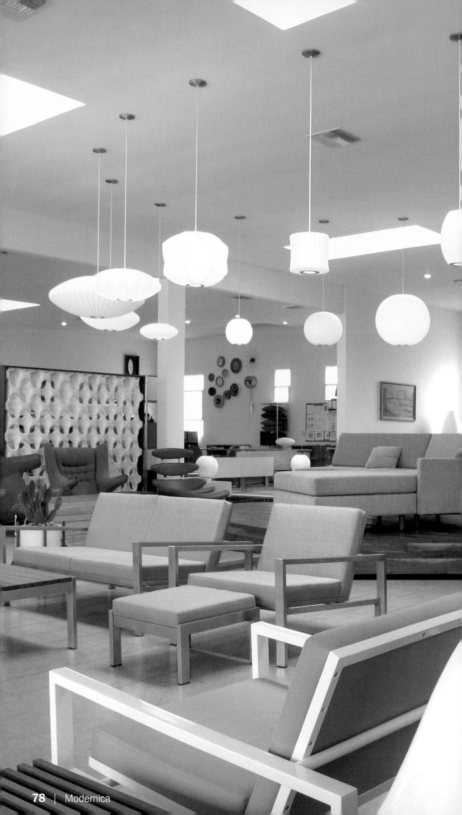

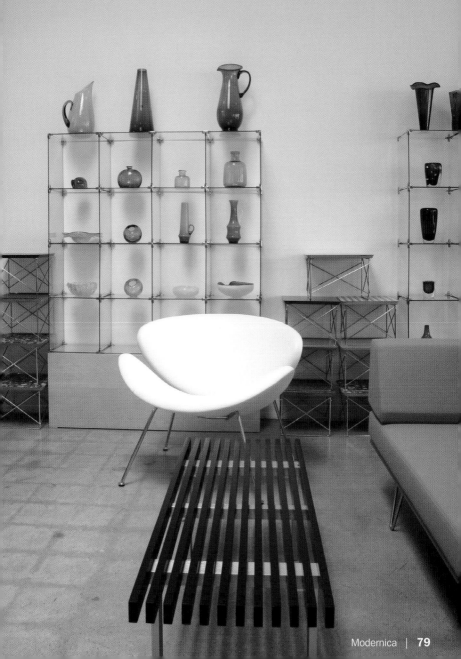

Monique Lhuillier

Design: Kelly Schandel, Abboud Malak, www.thinkpure.com

9609 Santa Monica Boulevard | Los Angeles, CA 90210 | Beverly Hills
Phone: +1 310 550 3388
www.moniquelhuillier.com
Opening hours: Daily 10 am to 6 pm
Products: Bridal & evening couture collection

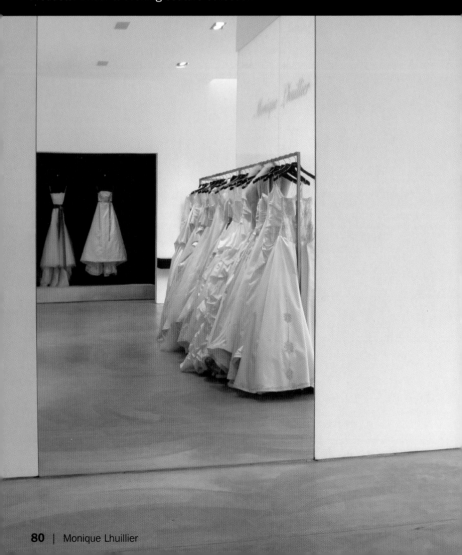

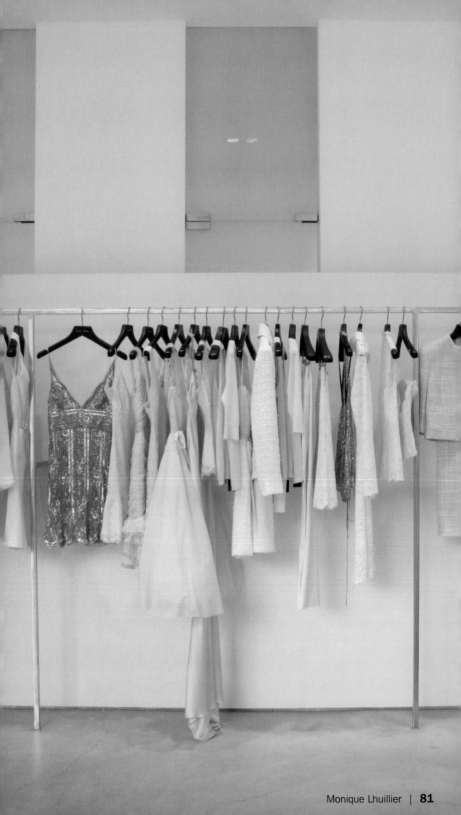

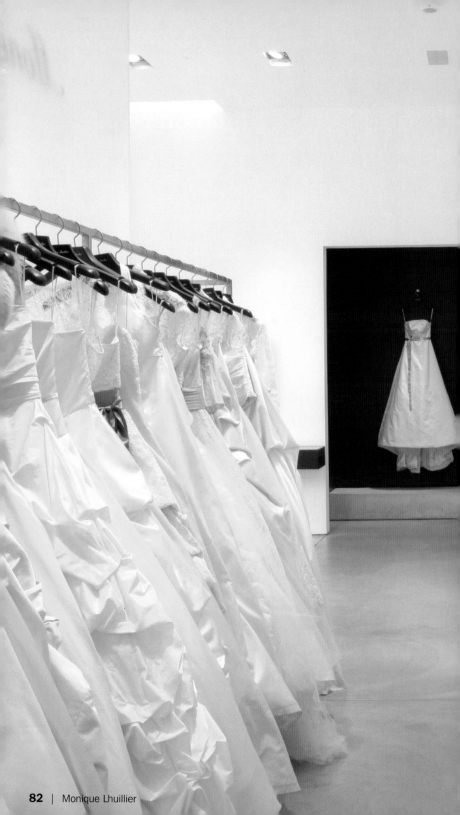

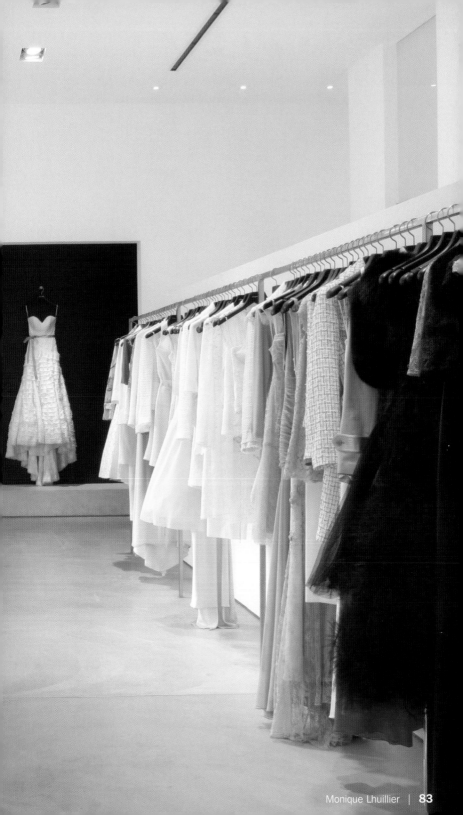

Munky King

Design: Patrick & Chanda Lam, www.munkyking.com

441 Gin Ling Way | Los Angeles, CA 90012 | Chinatown
Phone: +1 213 620 8787
www.munkyking.com
Opening hours: Mon–Thu noon to 7 pm, Fri noon to 8 pm, Sat 11 am to 9 pm,
Sun 11 am to 7 pm
Products: Designer vinyl toys, plush, mini figures, original art
Special features: Art exhibits, toy release parties, artist signings

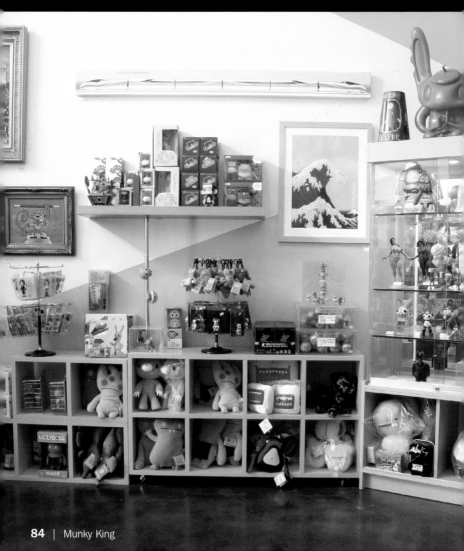

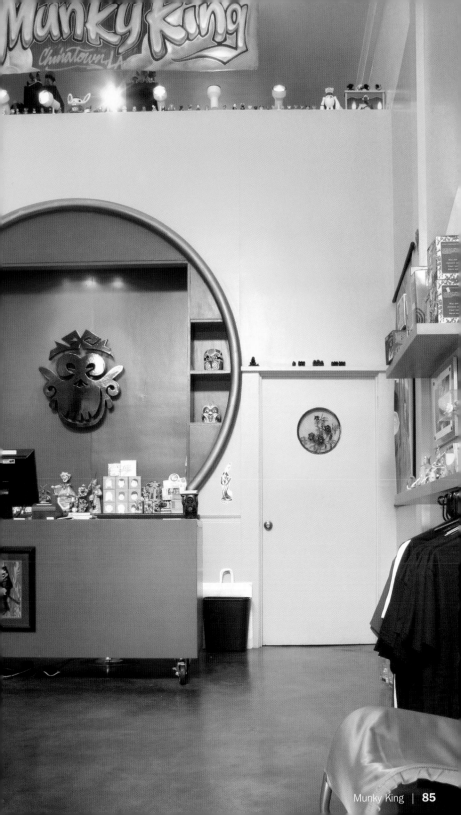

NOM Naissance on Melrose

Design: Joe Addo

8250 Melrose Avenue | Los Angeles, CA 90046 | West Hollywood
Phone: +1 323 653 8850
www.naissanceonmelrose.com
Opening hours: Mon–Sat 10 am to 6 pm, Sun noon to 5 pm
Products: Stylish maternity clothing, baby items, lotions & perfume
Special features: Netto collection furniture

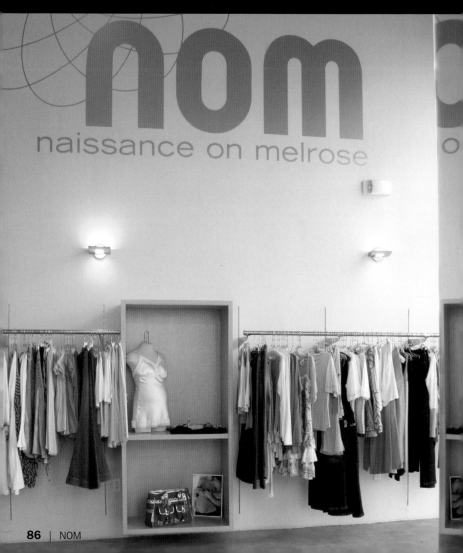

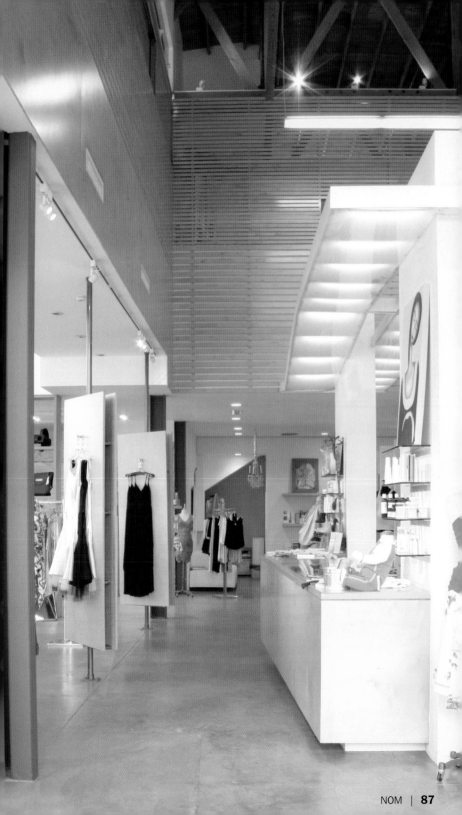

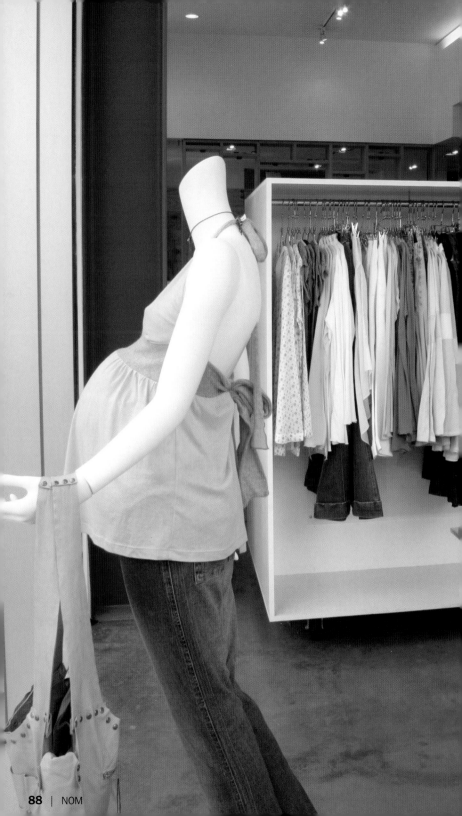

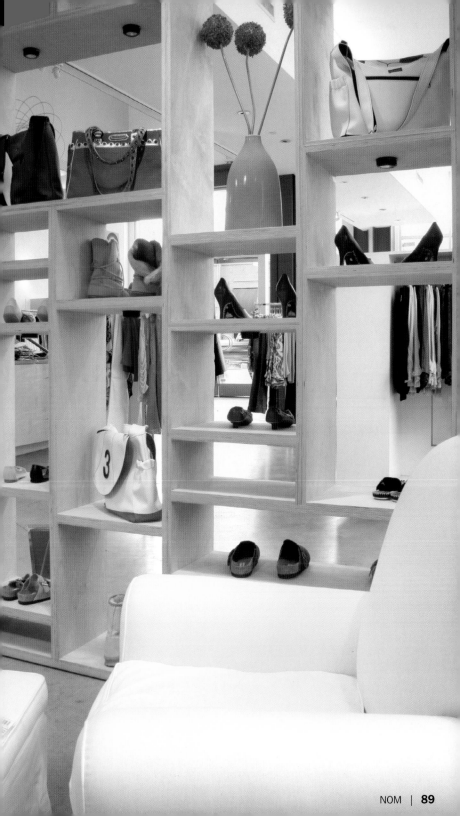

Noodle Stories

Design: John Friedman, Alice Kimm Architects Inc., www.jfak.ne

8323 West Third Street | Los Angeles, CA 90048 | Mid
Phone: +1 323 651 1782
Opening hours: Mon–Sat 10 am to 6 pm, Sun noon to 5 pm
Products: Woman's clothing, accessories, shoes, jewelry, gifts
Special features: International designer collections

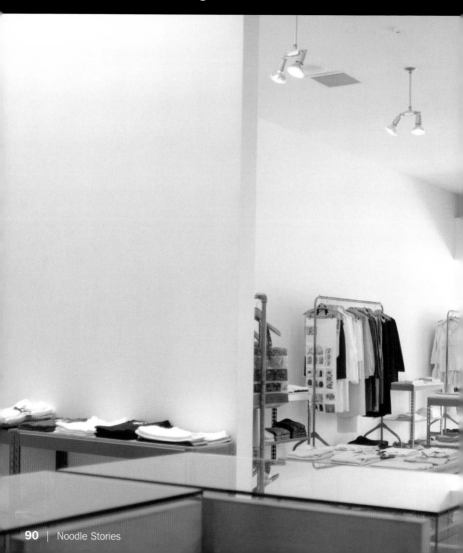

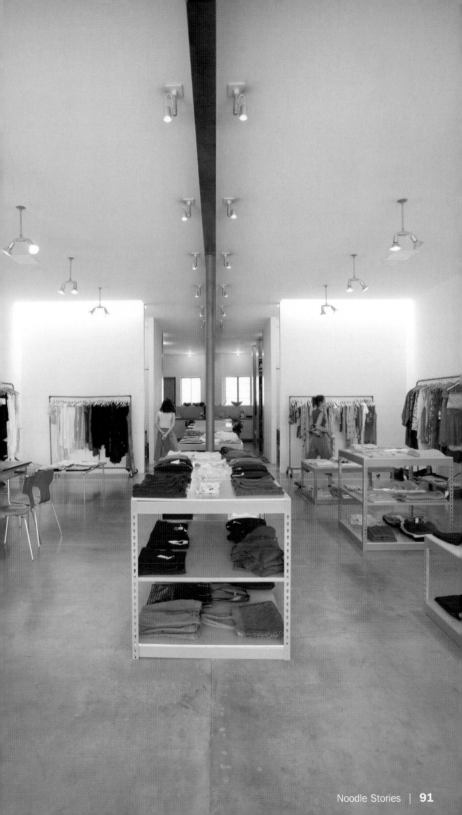

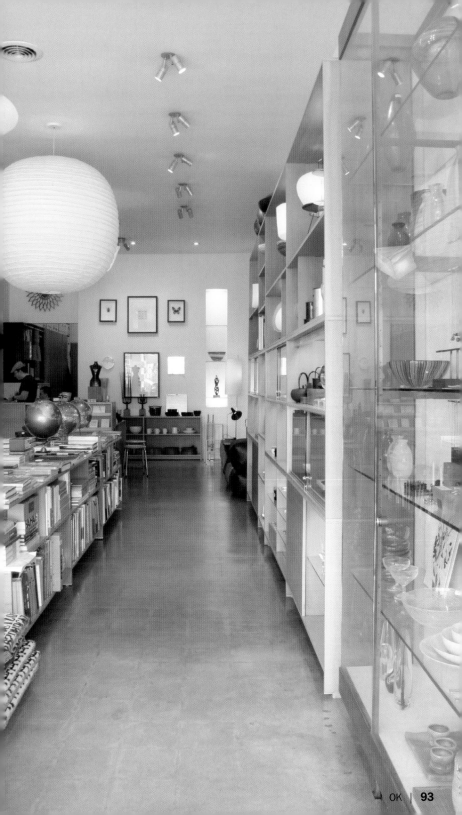

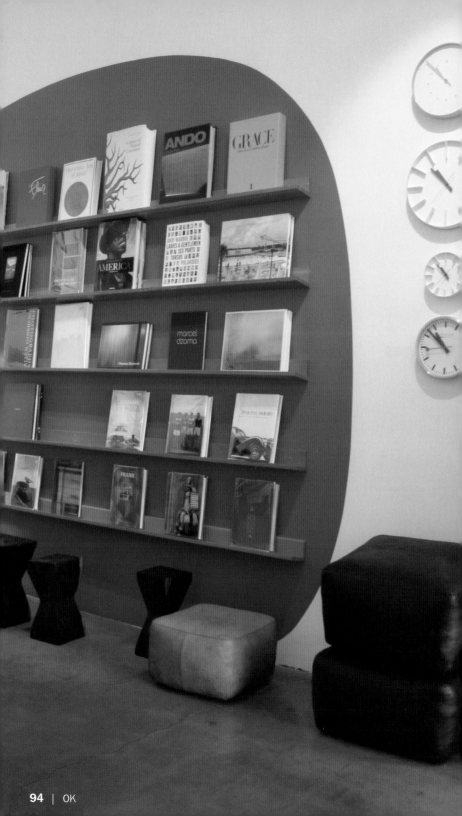

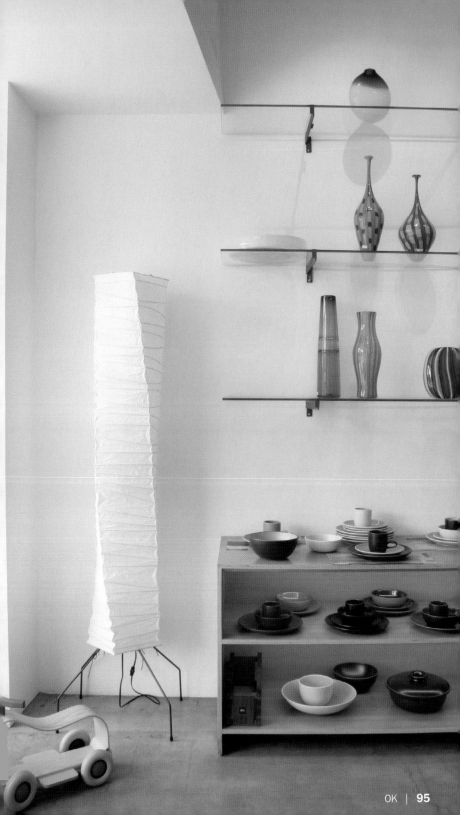

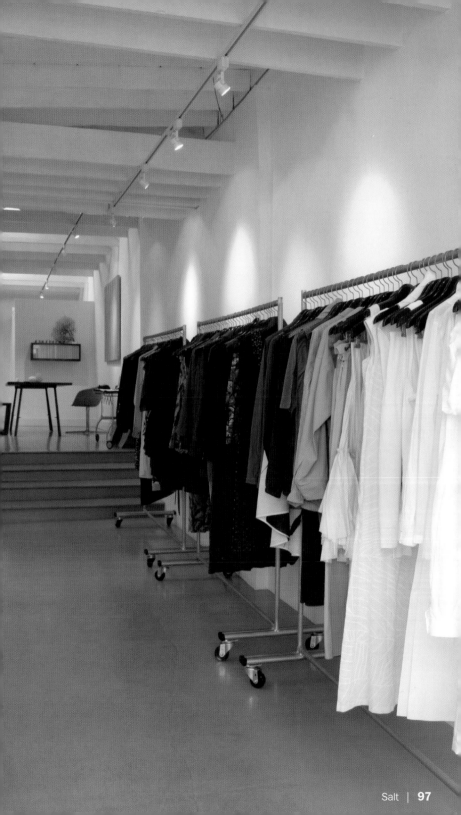

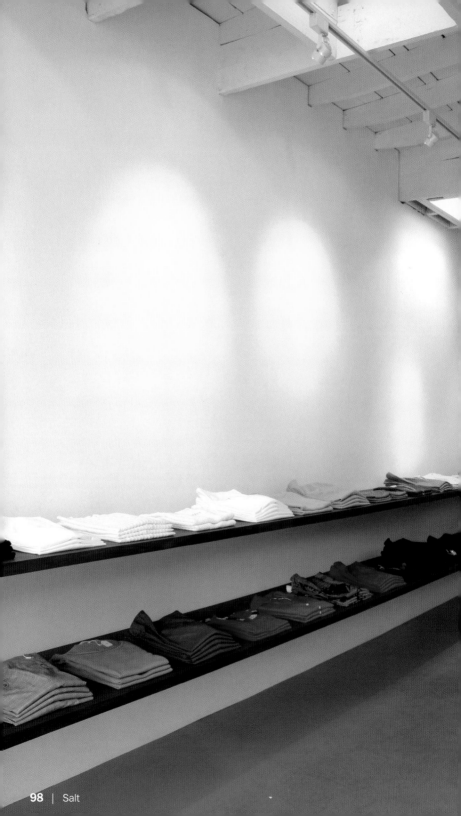

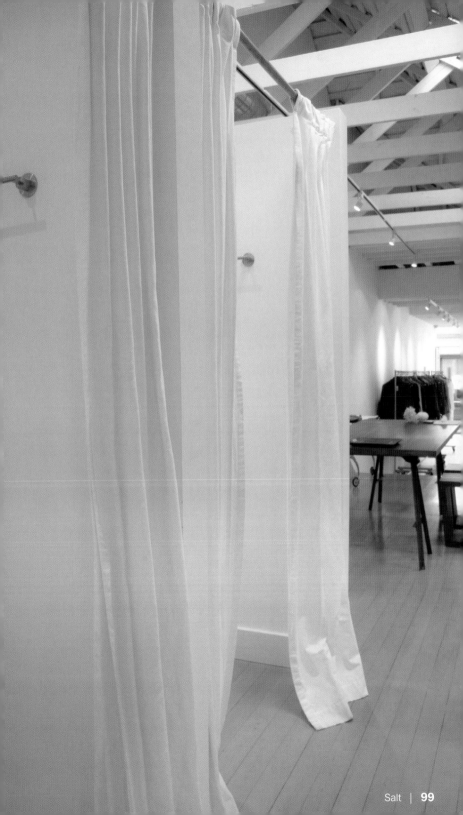

Scentiments

Design: Mark Billy

1331 Abbot Kinney Boulevard | Los Angeles, CA 90291 | Venice
Phone: +1 310 399 4110
Opening hours: Mon–Fri 9 am to 6 pm, Sat 10 am to 6 pm, Sun closed
Products: Full service florist
Special features: Event planning

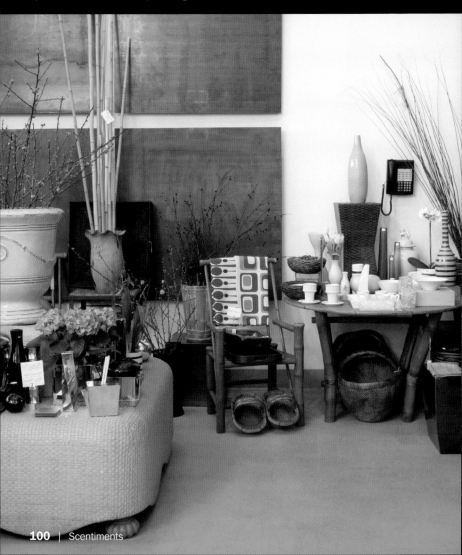

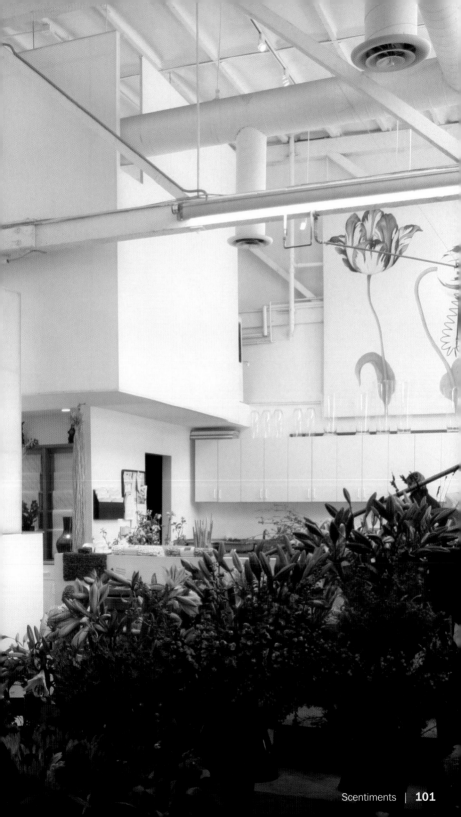

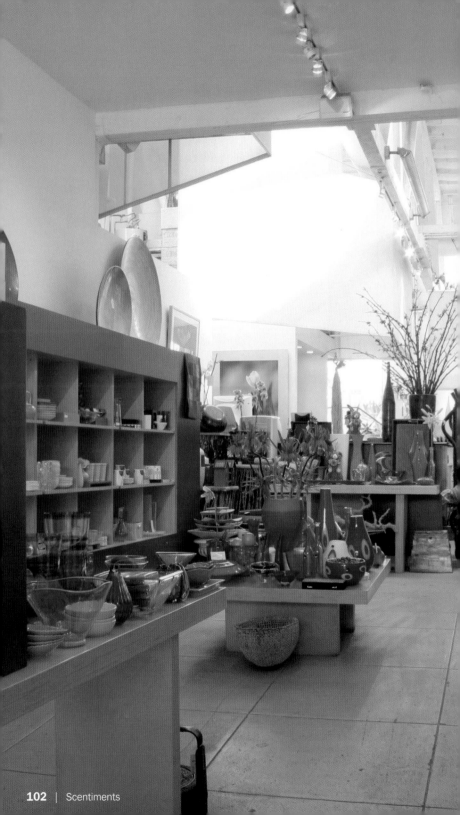

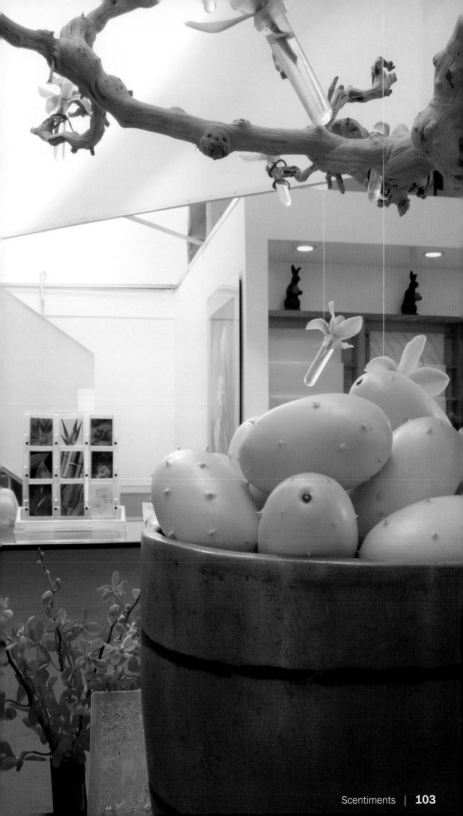

shelter

Design: Kamal Sandhu & Jay Dunton

7920 Beverly Boulevard | Los Angeles, CA 90048 | West Hollywood
Phone: +1 323 937 3222 or +1 310 451 3536
Opening hours: Mon–Sat 11 am to 7 pm, Sun noon to 5 pm
Products: Modern furniture, home accessories, linens, rugs, lamps, framed art, table tops, books & more
Special features: All furniture is stocked

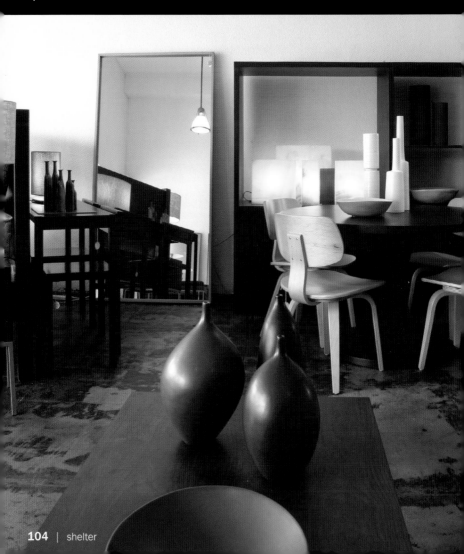

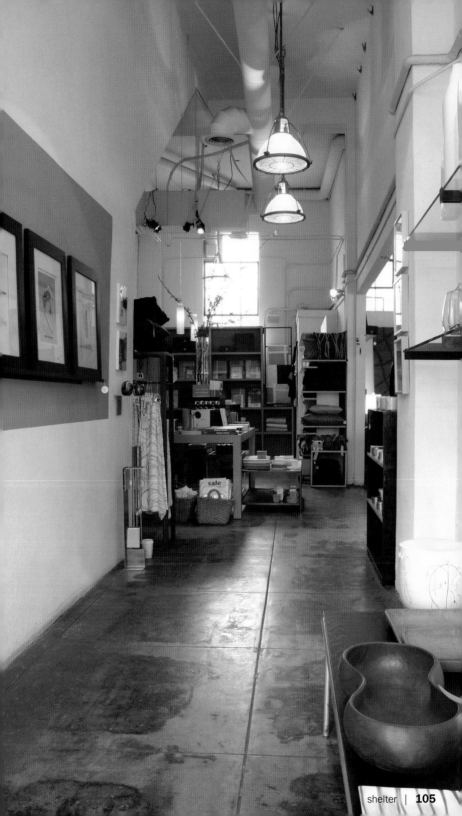

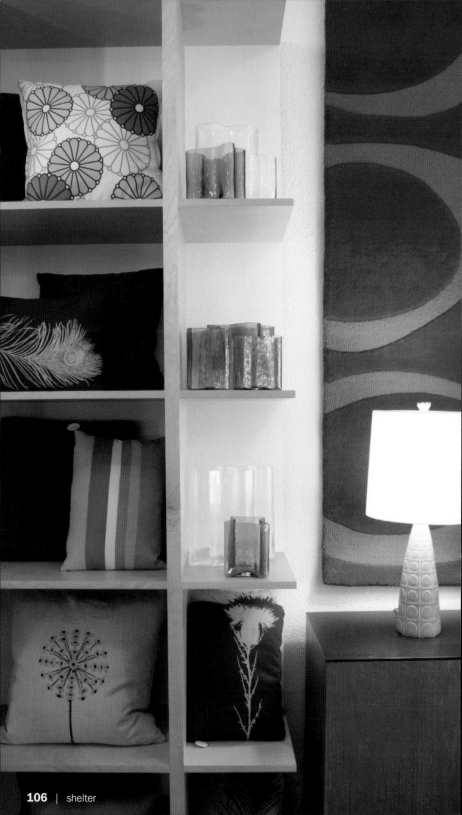

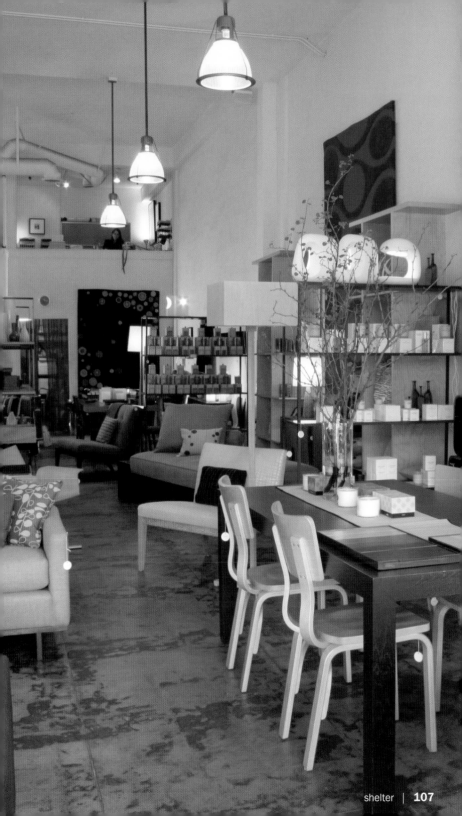

Silverlake Wine

Design: Ana Henton, www.anahentondesign.com

2395 Glendale Boulevard | Los Angeles, CA 90039 | Silverlake
Phone: +1 323 662 9024
www.silverlakewine.com
Opening hours: Sun–Wed 11 am to 9 pm, Thu–Fri 11 am to 10 pm, Sat 10 am to 10
Products: Wine & beer
Special features: Three weekly tastings, private tastings for groups and individuals

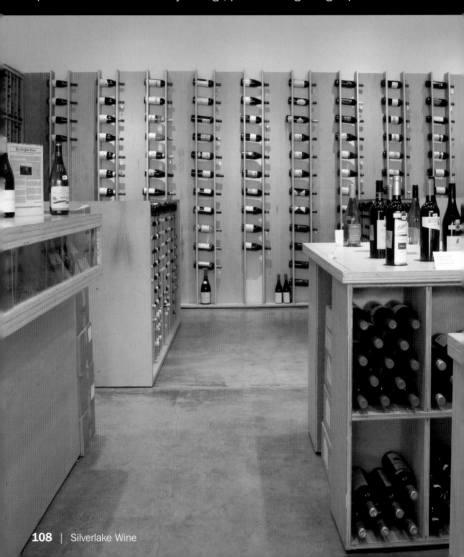

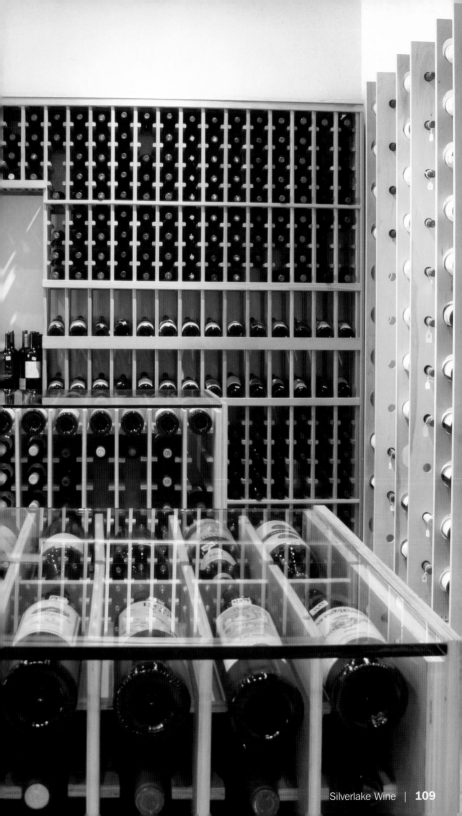

Soolip

Design: Grant Forsberg

8646 Melrose Avenue | Los Angeles, CA 90069 | West Hollywood
Phone: +1 310 360 0545
www.soolip.com
Opening hours: Mon–Sat 10 am to 6 pm, Sun noon to 5 pm
Products: Handmade papers, cards, custom letter press invitations
Special features: Gift wrapping service, custom letterpress designers on site to help
design personal stationery and invitations

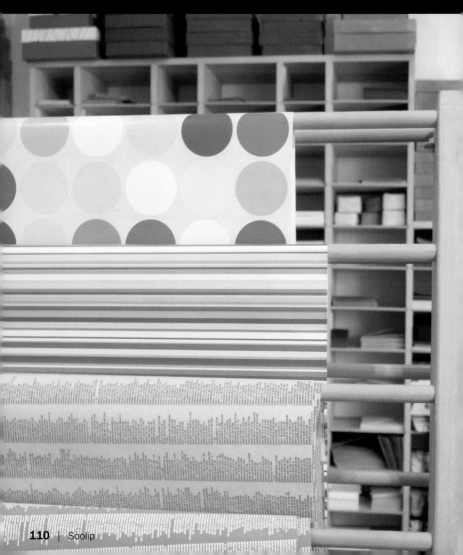

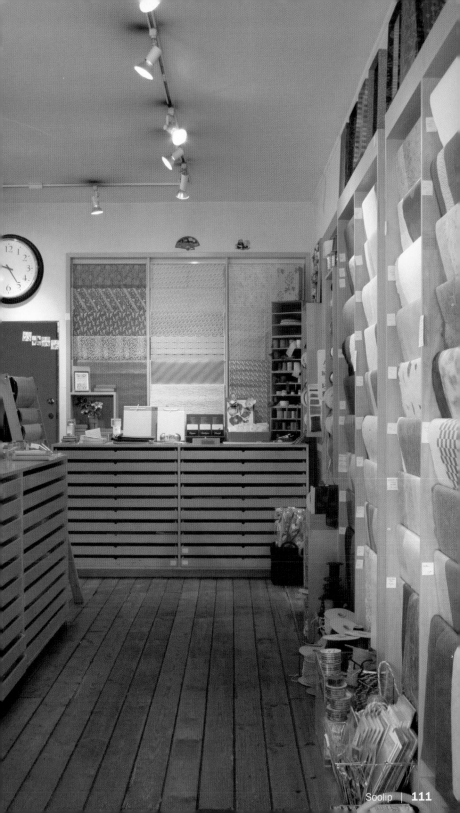

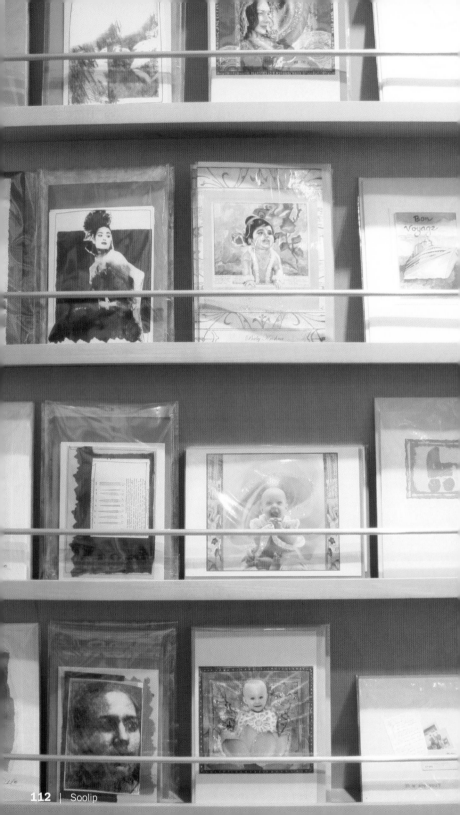

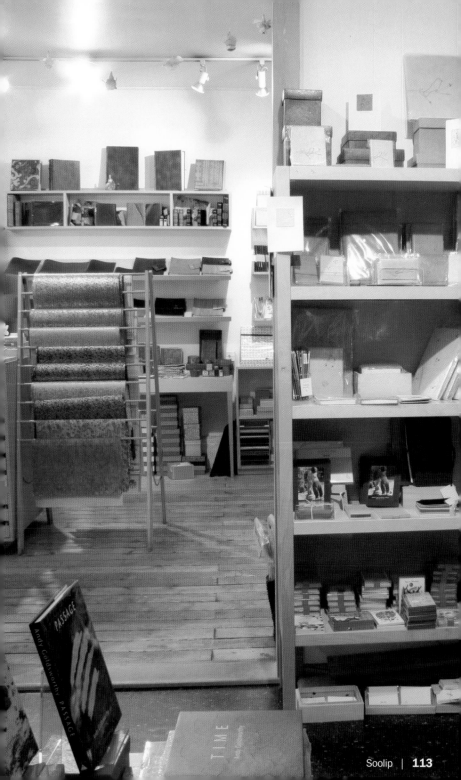

Stella McCartney

Design: Universal Design Studio London in collaboration
with Stella McCartney

8823 Beverly Boulevard | Los Angeles, CA 90048 | West Hollywood
Phone: +1 310 273 7051
www.stellamccartney.com
Opening hours: Mon–Sat 11 am to 7 pm, Sun closed
Products: Ready-to-wear design clothing, lingerie, accessories, shoes & eyewear
Special features: Large changing room, green house

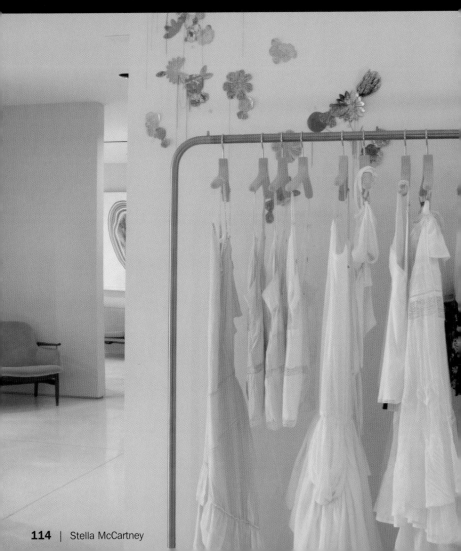

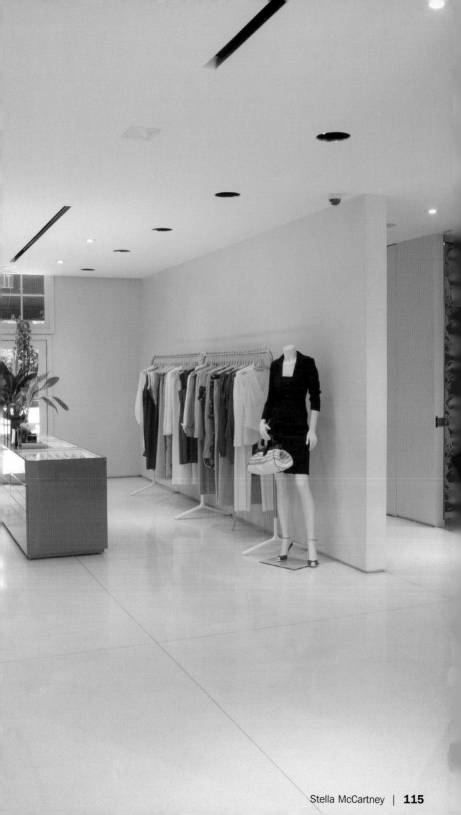

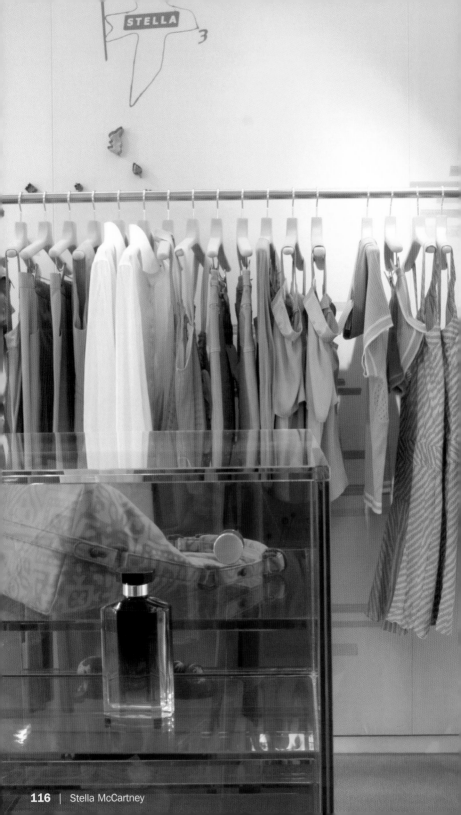

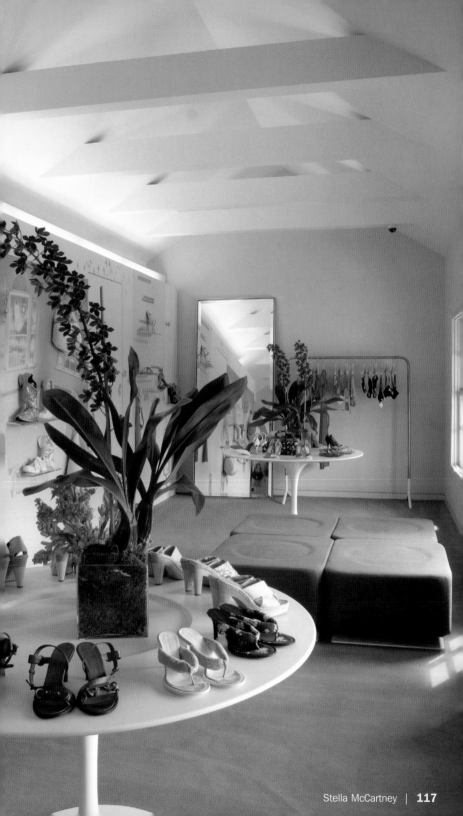

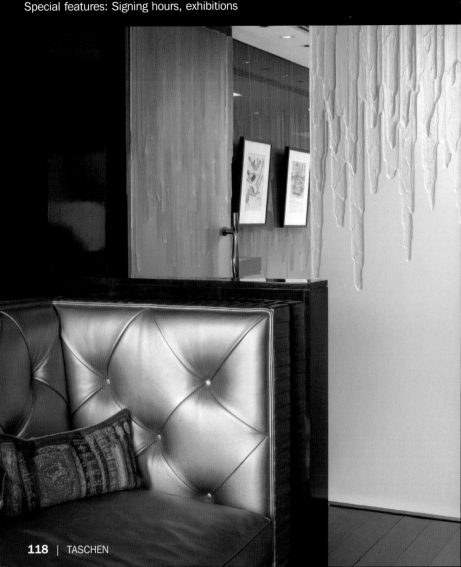

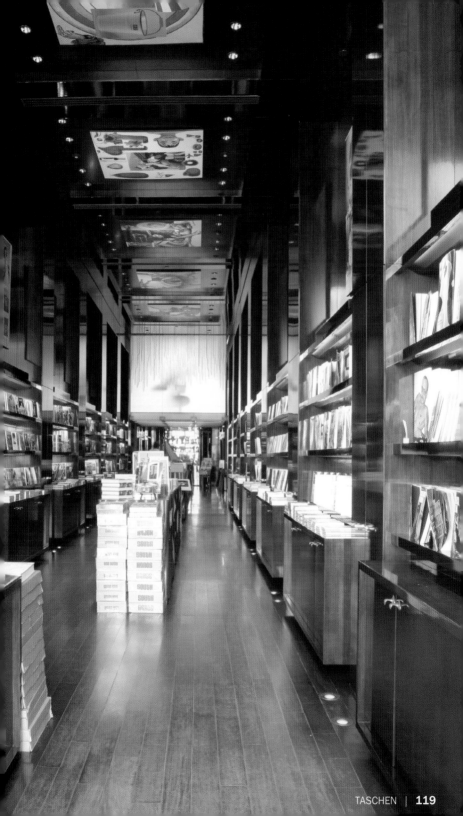

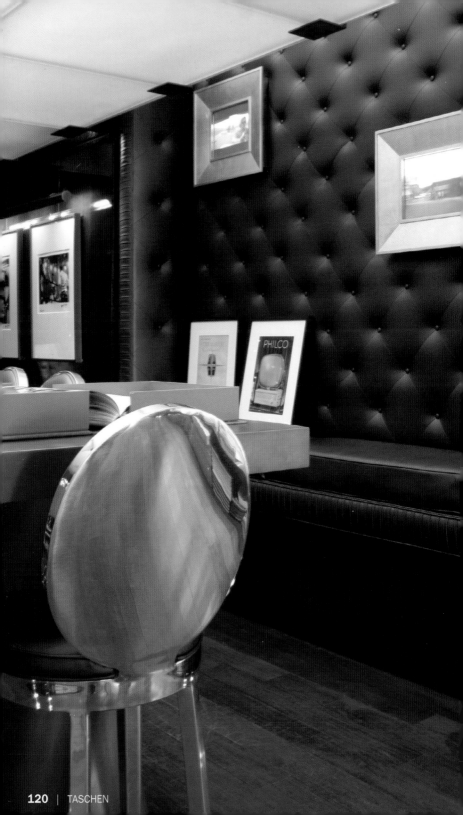

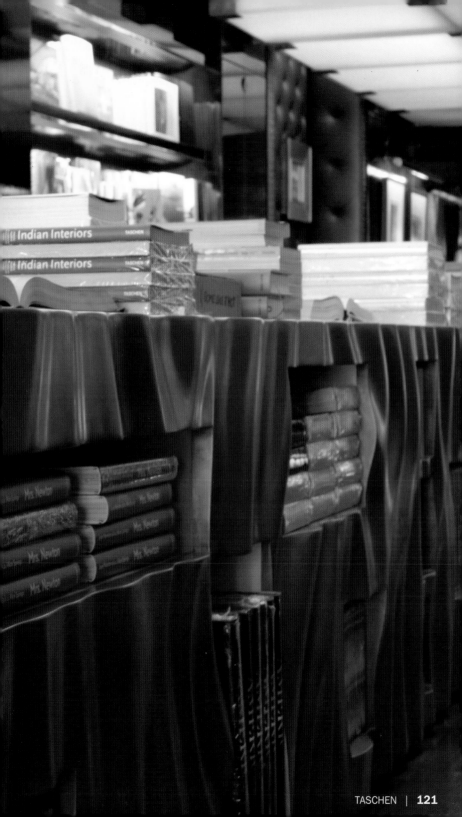

Trina Turk Los Angeles Boutique

Design: kwid, Kelly Wearstlera, www.kwid.com

8008 West Third Street | Los Angeles, CA 90048 | West Hollywood
Phone: +1 323 651 1382
www.trinaturk.com
Opening hours: Mon–Sat 11 am to 7 pm, Sun noon to 5 pm
Products: Clothing both for men and women
Special features: Hip retro-inspired sportswear

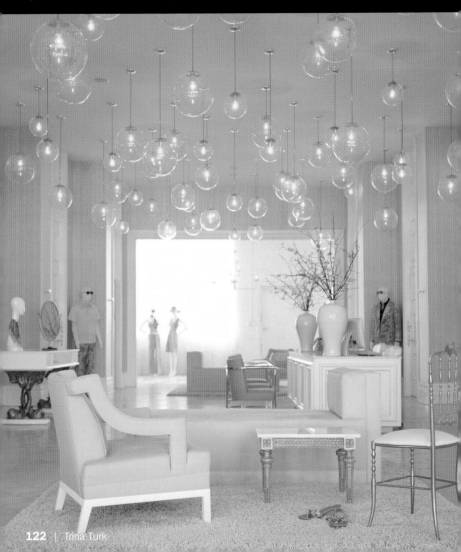

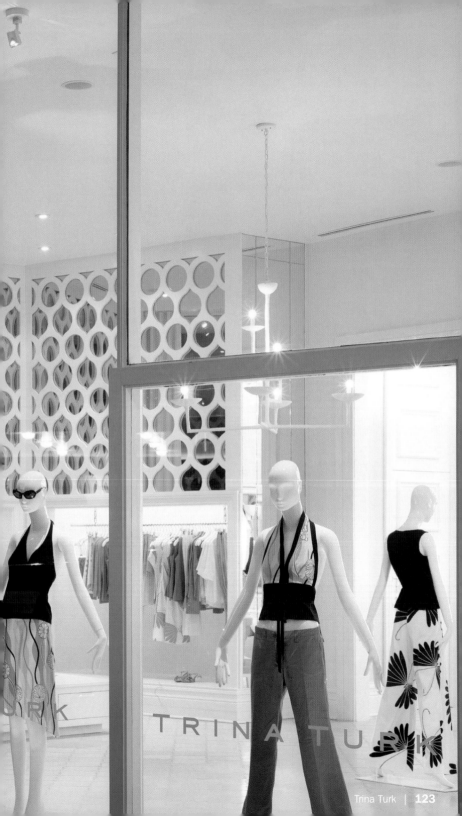

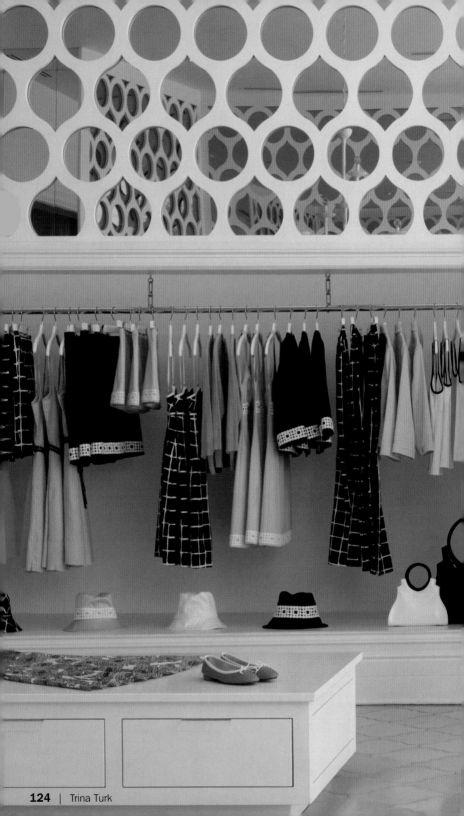

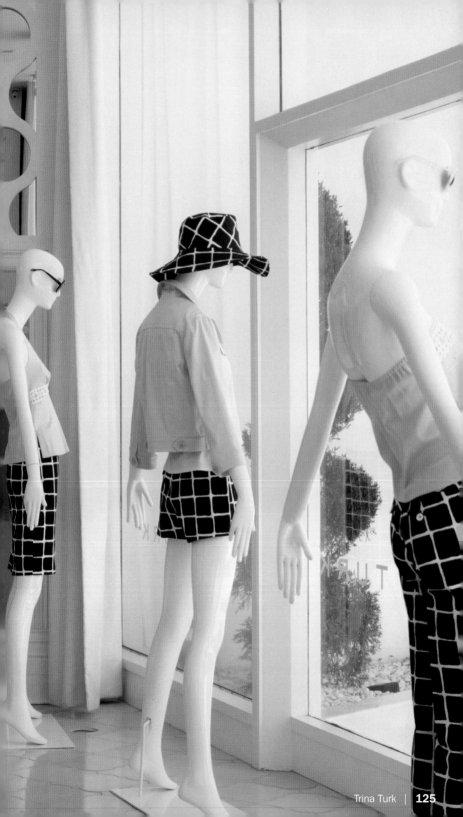

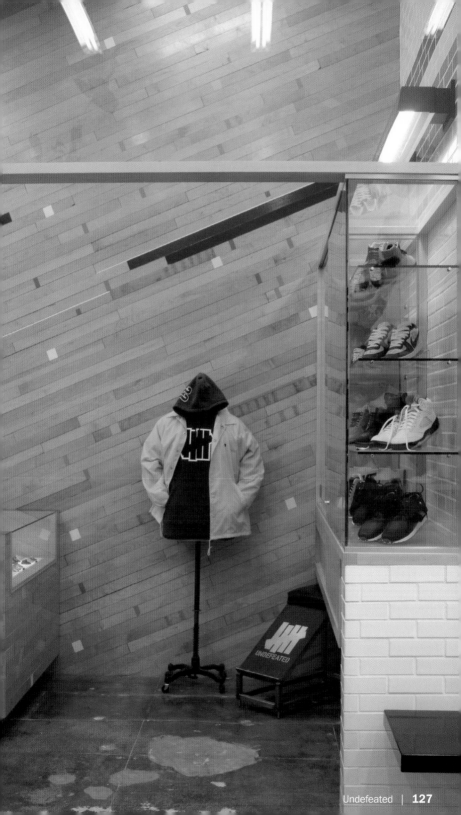

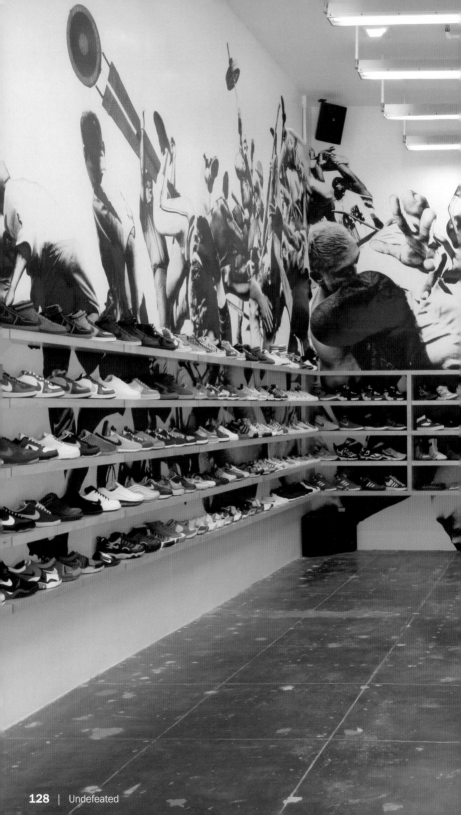

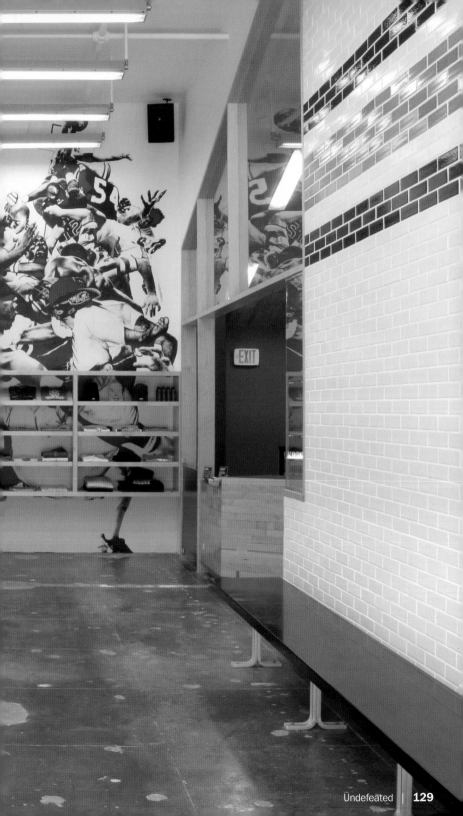

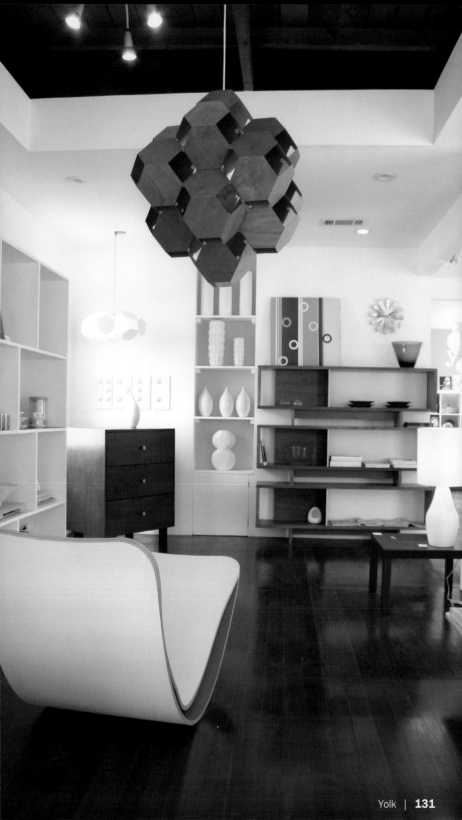

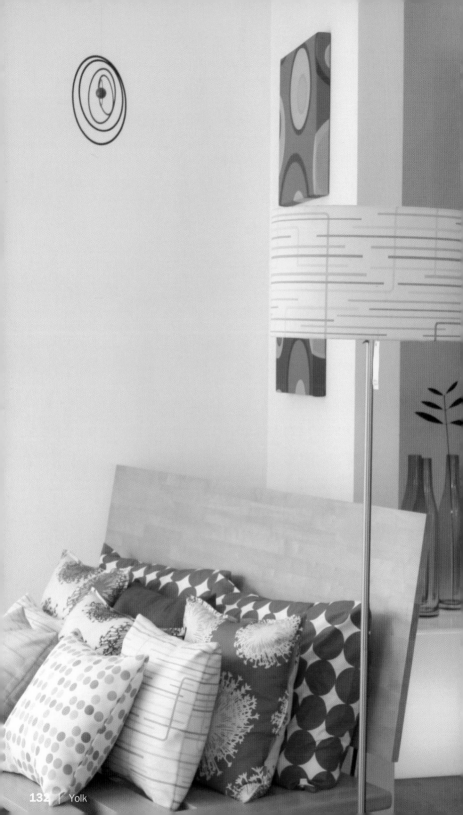

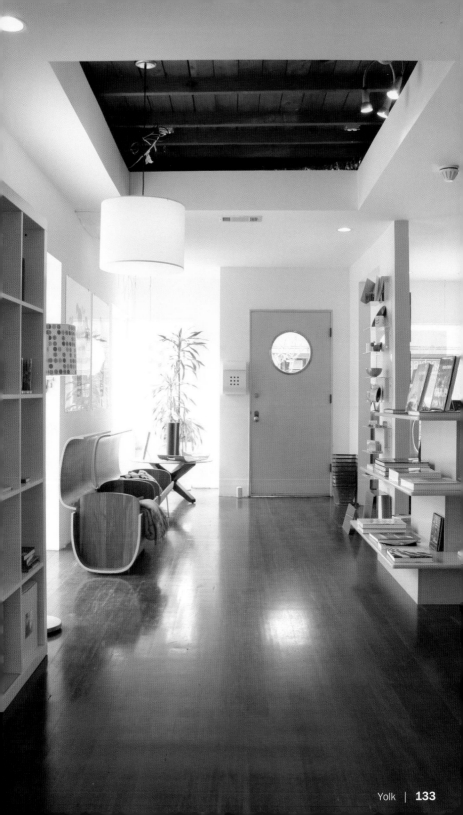

No.	Shop	Page

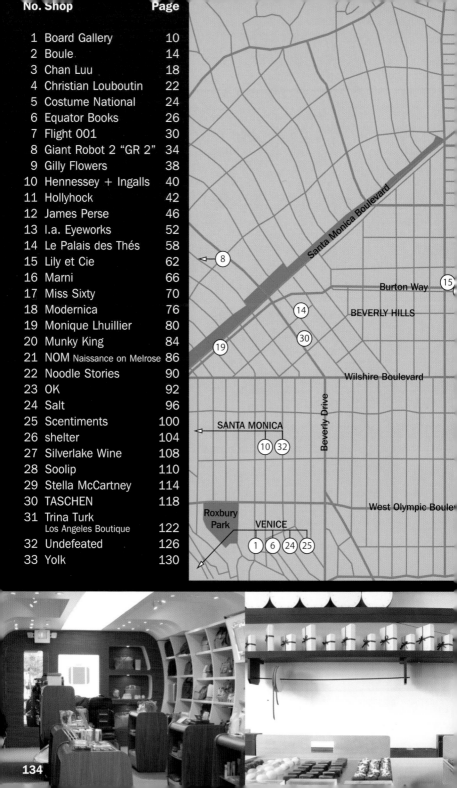

Santa Monica Boulevard

Burton Way

BEVERLY HILLS

Wilshire Boulevard

Beverly Drive

SANTA MONICA

West Olympic Boule

Roxbury Park

VENICE

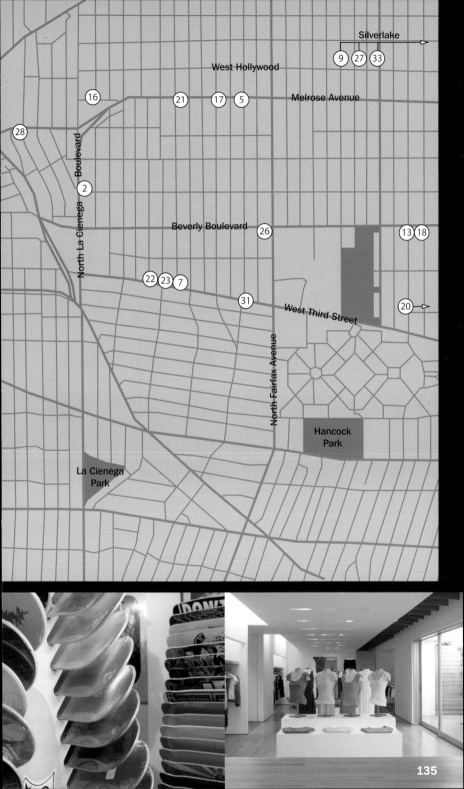

Silverlake

West Hollywood

Melrose Avenue

North La Cienega Boulevard

Beverly Boulevard

West Third Street

North Fairfax Avenue

Hancock Park

La Cienega Park

COOL SHOPS

Size: 14 x 21.5 cm / 5 $\frac{1}{2}$ x 8 $\frac{1}{2}$ in
136 pp
Flexicover
c. 130 color photographs
Text in English, German, French,
Spanish and Italian

Other titles in the same series:

ISBN
3-8327-9073-X

ISBN
3-8327-9070-5

ISBN
3-8327-9038-1

ISBN
3-8327-9022-5

ISBN
3-8327-9072-1

ISBN
3-8327-9021-7

ISBN
3-8327-9037-3

**To be published in the
same series:**

Amsterdam
Dubai
Hamburg
Hong Kong
Madrid
Miami

San Francisco
Shanghai
Singapore
Tokyo
Vienna

teNeues